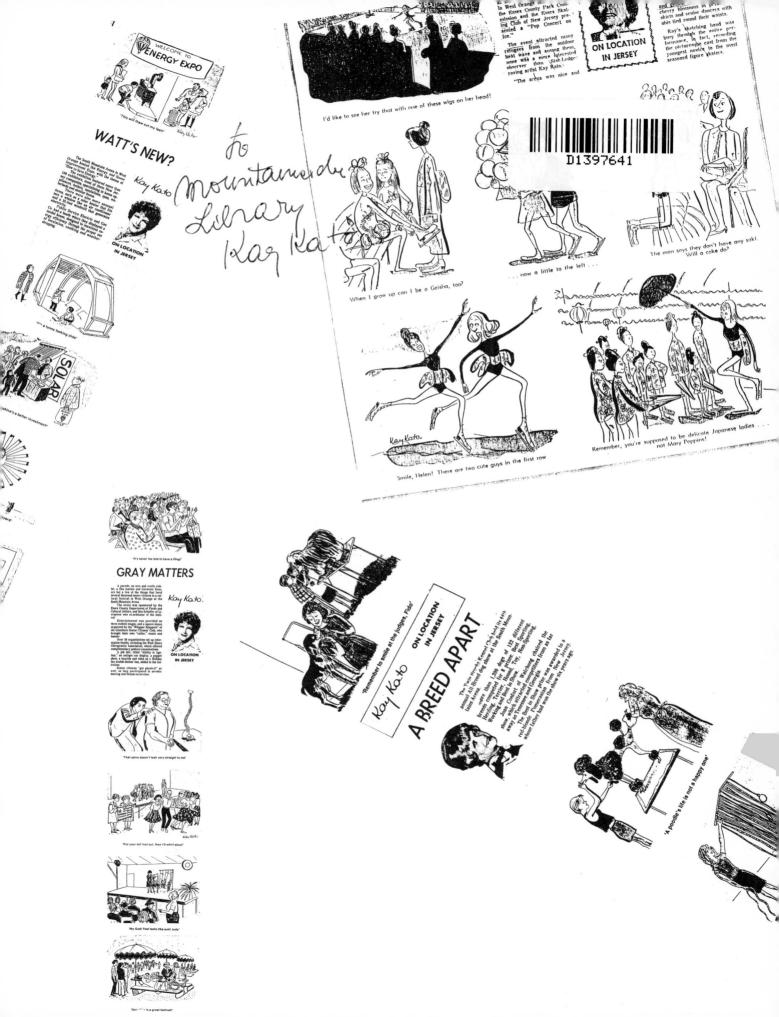

ESSEX COUNTY PARKS CENTENNIAL COMMITTEE INC.
A New Jersey Non-Profit Corporation
115 Clifton Avenue, Newark, New Jersey 07104
(973) 268-3500
James W. Treffinger, County Executive

Centennial Committee
Louis LaSalle, Chairperson
Frank Cocchiola, Vice Chairperson
Quilla Talmadge, Secretary
Michael Colitti, Treasurer
Kathleen P. Galop, Esq.

Honorary Chairperson
Hon. Christine Todd Whitman

Honorary Co-Chairpersons
Hon. Brendan T. Byrne
Hon. Thomas H. Kean

To the Reader:

In recognition of the 100th Anniversary of the creation of America's First County Park System, the Essex County Park's Centennial Committee was established to commemorate this milestone. A year long series of events and celebrations was held, starting off with the cutting of a Birthday Cake in March 1995 at the Branch Brook Roller Rink in Newark, N.J.

While thousands of Essex County citizens enjoyed the many Centennial festivities, the Centennial Committee remained committed to recognizing the significance of this event through the publication of a book featuring the Essex County Park System. A *1995 Historic Profile* was being compiled by a dedicated volunteer, Paul R. Jackson (President-1st Mountain Chapter of the Sons of the American Revolution) of West Orange, N.J. Unfortunately, Mr. Jackson's untimely death put an end to the project.

Then most unexpectedly, the noted columnist from the *Sunday Star-Ledger*, Kay Kato, approached the Centennial Committee about publishing excerpts from her columns and drawings featuring the Essex County Park System into a book for the benefit of the Park System. Kay Kato has graciously offered to donate all of her royalties from the publication of this book to the Essex County Parks Centennial Committee. Even, more importantly, Ms. Kato has worked tirelessly on the preparation of these materials for publication.

Thus, *Park Art*, was born, but it couldn't become a reality until funds for the publishing costs were raised. Our corporate and foundation friends have generously offered to underwrite the publication costs enabling the Centennial Committee to print *Park Art*. This entertaining book serves as a lasting tribute to the first 100 years of the Essex County Park System. Look closely, you may find yourself in one of Kay's delightful drawings.

The Centennial Committee wishes to publicly thank the following corporations and foundations for their critical financial support of this project: Amelior Foundation; Bell Atlantic; Broad National Bank; CIT; Saint Barnabas Health Care System; Seton Hall University; The Manor; PSE&G; The Prudential Foundation; and Victoria Foundation. The Centennial Committee also takes this opportunity to thank Leonard J. Fisher, Associate Editor of *The Star-Ledger* and Pearl Pye, the widow of Mort Pye (former Editor-in-Chief of *The Star-Ledger*) for their support and encouragement.

All proceeds from the sale of *Park Art* will go to enhance the Essex County Park System for the next 100 years.

With Thanks,

Louis LaSalle

Louis LaSalle

Essex County Celebrates the 100th Anniversary of the Nation's First County Park System

PARK ART

with
PAD & PENCIL
in the Parks
for 31 Years

by

Kay Kato

Noted Columnist of the

Sunday Star-Ledger

The Donning Company/Publishers
184 Business Park Drive, Suite 106
Virginia Beach, VA 23462

Steve Mull, *General Manager*
Dawn V. Kofroth, *Assistant General Manager*
Mary Taylor, *Project Director*
Shannon H. Garza, *Associate Editor*
Sally C. Davis, *Keystroker*
John Harrell, *Imaging Artist*
Teri S. Arnold, *Director of Marketing*

Library of Congress Cataloging-in-Publication Data

Kato, Kay.
 Park art : with pad & pencil in the parks for 31 years from the Sunday
Star-ledger / by Kay Kato.
 p. cm.
 ISBN 1–57864–063–6 (hardcover : alk. paper)
 1. American wit and humor, Pictorial. 2. Star-ledger (Newark,
N.J.) I. Title.
NC1429.K285A4 1999
741.5'973—dc21
 99–10113
 CIP

Printed in the United States of America

Table of Contents

Foreword

More than thirty years ago, a gracious, unassuming woman, carrying a portfolio of cartoons, walked into *The Star-Ledger* office. As she started to open the portfolio, it seemed she would become the latest in the parade of would-be artists with ambitions to do political cartooning.

That was a natural assumption, since most cartoonists who come into a newspaper office would like to produce hard-hitting, biting political commentary. Few succeed.

But as she started to spread out examples of her work, it was clear politics had nothing to do with her visit. Her objective was different. To "cover" in her inimitable style everyday activities of "average" men, women, and children in New Jersey.

The examples of her work published in some of the top national magazines, including *Parade, The New York Times Magazine,* and *The Saturday Evening Post,* made it obvious she was an extremely talented artist. How that talent would be applied in dealing with local situations, however, was a question.

Though tending toward modesty, she was firmly confident of her ability to provide a different and interesting feature. She just wanted a chance.

It seemed an intriguing idea, for one thing, to let her take the place of a photographer at some activities in the state and see how it would work out. In short, we decided to give her a chance—and it was a decision we never regretted.

We called the project "Kay Kato on Location in Jersey" and it has been a regular feature of the *Sunday Star-Ledger* for thirty-one years. In all that period, no one on the paper can remember any week when she failed to produce her sketches.

As time went on, she extended her range. The "location" might be anything from a backyard barbeque to a State House ceremony. But always she approached the subjects of her sketches with a perceptive eye for the human, down-to-earth qualities that, it soon became apparent, appealed to a wide audience.

She once described her own work to a reporter in this fashion:

I try to show the lighter side of life. We usually laugh later at things, but I like to show we can laugh now. I pick out things that interest me. The things that interest me I think will be of interest to the reader.

These days when readers seem to be yearning for a bright note to balance the barrage of depressing news, Kay Kato's "On Location" is certainly a welcome diversion. While she may see people's foibles, she simply views them in a sympathetic, understanding manner. Her forte, in her own words, is "the lighter side." And she has developed an expertise in ferreting it out—much to the delight of *Star-Ledger* readers.

Newspaper editors tend to think on daily terms: what's new for tomorrow's paper. Sometimes we neglect to pay proper attention to the historical perspective.

We are more intent putting a focus on events as they rush by. And so it is with Kay Kato. Each individual sketch catches a fleeting glimpse of people and events. But more than eight thousand sketches compiled over more than thirty years comprise an overview of a third of a century of life in the Garden State.

A panorama of life in New Jersey will be preserved for posterity with the publication of the work of Kay Kato "On Location." It is a chronicle that has delighted New Jerseyans for many years—and this book will extend the same opportunity to New Jerseyans in the future.

—Mort Pye (1918–1997)
Editor-in-Chief of *The Star-Ledger*
(1963–1995)

Introduction

Park Art is a collection of columns from my years as a sketching columnist for *The Star-Ledger*, a Newhouse newspaper and the largest paper in New Jersey with close to two million readers every Sunday. My weekly column called: "On Location in Jersey" is seen as a pictorial history of the state. Because of its diversity, New Jersey itself can be seen as a microcosm of America, thus, everything pictured here is relevant to all areas of the country.

The drawings for this book were chosen from the eighty-five hundred or so that appeared in sixteen hundred weekly columns, spanning thirty-one years. More than one hundred of these columns featured the Essex County Park System.

The programs, events festivals, and sports events that took place within the parks were depicted in the columns. With pad and pencil in hand, I covered an immense variety of happenings: from bees to elephants; from "Met in the Park" to a diaper derby; from rose pruning to a Youth Festival; from a Golf Classic to African drummers, always looking for and, on most occasions, finding humor in every situation. My aim as a sketching reporter was to record the unrepeatable character of life and present the essence of the moment with a few simple flowing lines. There are four chapters: Zoo, Essex County Parks, Center for Environmental Studies, and Arena.

The drawings are the center of attention. Explanatory text accompanies each subject and sketch. Readers will recognize not just the events they attended, but themselves as well.

Park Art is a fundraiser for the Essex County Department of Parks, Recreation and Cultural Affairs, with all the proceeds to benefit this great organization. When I heard that the zoo might have to be closed, I offered to help by donating my book as a fundraiser and donating my royalties to this good cause.

Everyone connected with the book worked as a volunteer. I'd like to give special thanks to: Mr. Louis LaSalle, Chair of the Essex County Parks Centennial Committee; and to all the Members of the Centennial Committee: Kathleen P. Galop, Michael Coletti, Frank Cocchiola, Quilla Talmadge, Barbara Bell Coleman and John Smith; and Daniel K. Salvante, Director of the Essex County Department of Parks, Recreation and Cultural Affairs. Special thanks to *The Star-Ledger* for the privilege of working for them for three decades and for their cooperation with this publication. My thanks go to Jeanne Andrea Benas, Illustrator, Art Director—for her encouragement, help, and advice.

The cost of publishing *Park Art* has been subsidized by generous corporate sponsors and foundations.

This book is dedicated to: Jeanne Andrea, Rick, and Adam.

—Kay Kato

Chapter 1

Chapter 1 **Zoo**

1. Petting Zoo

"Zoo's Who"
July 25, 1965

The animals have known it for years: there's no better spot for people-watching than a zoo.

One of the most interesting zoos around is the Essex County Park Commission's Turtle Back Zoo in the South Mountain Reservation, West Orange, where the animals have almost as much mobility as the two-legged visitors.

"Where else," asks Kay, "can you sketch a llama with a buffalo looking over your shoulder; be kissed on your drawing arm by a friendly calf; or lose a bite of paper to a hungry goat?"

"Honestly, dear, an octopus does not eat little girls!"

"No, Evelyn. You can NOT bring your chemistry set here to experiment."

"That's funny. I thought I saw the kids here a minute ago . . ."

"Another bath? Haven't you heard about the water shortage?"

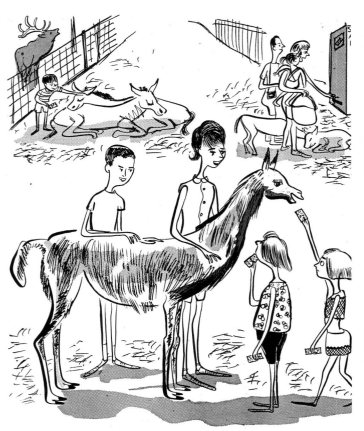

"Hey, mom. This stuff tastes good!"

2. Train Ride

"Train Ride"

June 9, 1968

This attraction at the zoo is named the Turtle, Orange, and Essex Railroad Limited. For 30 cents a ride it circles a one-mile run around the Orange Reservoir.

There's a real-live aura of Civil War history.

At the helm is a college student from Livingston, who informs his patrons that the zoo is not responsible for delays caused by buffalo on the tracks nor attacks from hostile Indians.

The children's anticipation of stampeding buffalo and charging Indians did not materialize, but there was a moment's delay for a squirrel who parked himself on the tracks.

"Whadda ya mean the buddy system; my dad told me to be an individual."

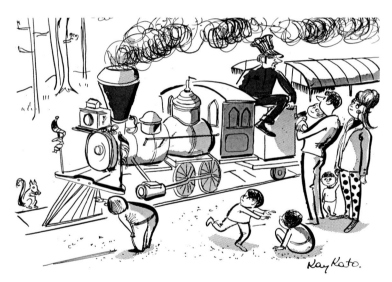

"No buffalo, folks, but we do have a squirrel."

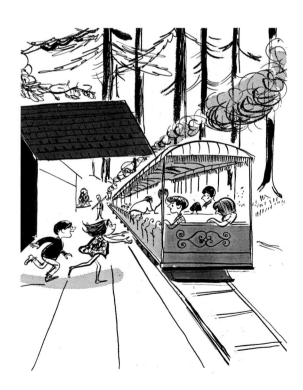

"First come, first served; you'll have to sit in the middle."

"I wanna hold your hand."

"I told him I'd carry him if he'd carry the umbrella."

3. Zoo in Winter

"A Happy Hibernation"
January 3, 1971

"*What do you mean, do I have any spare change?*"

Did you ever wonder what happens to the animals in the zoo when winter arrives?

I visited the Turtle Back Zoo in West Orange to see what's become of the animals when Jack Frost is nipping at their paws.

I found two otters keeping animal attendant Peter Stroup of Livingston company as he shoveled some snow.

"*I never heard of a snake with a pair of skiis either, but I wasn't going to take them away from him.*"

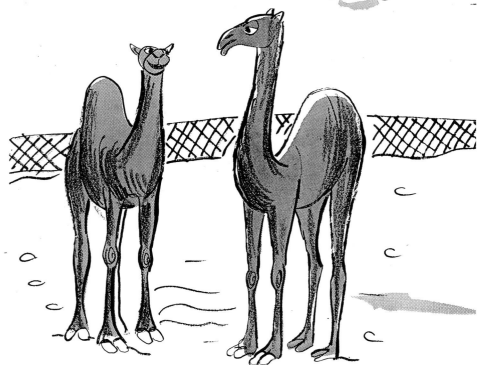

"*Snow, snow, snow . . . I told you we should've jumped ship in Frisco.*"

4. Zoo Story

"The Story Turtle"

July 2, 1978

Every Tuesday and Thursday at 2 p.m. the Story Book Hour starts at the Turtle Back Zoo in West Orange.

Small children and their mothers gather outside the education center under the tall trees near the animal nursery and wait for the appearance of Vince Sharp, an educational coordinator who brings a lot of carrying cases with animals sitting in them.

"When opossums hang around together, they do it like this."

"Watch out, lady—you're dropping some of him."

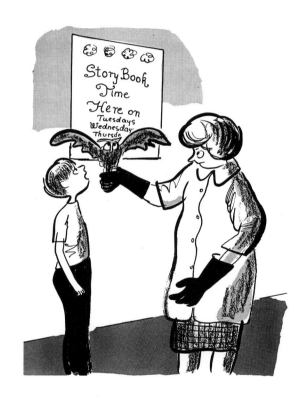

"He doesn't look so smart to me."

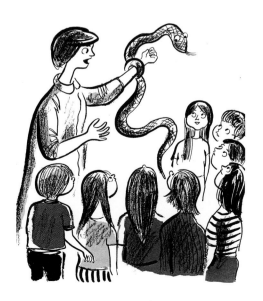

"He has a cousin who's very big in rock 'n' roll."

5. Story Book Time

"A Storied Zoo"
September 15, 1974

Every Tuesday, Wednesday, and Thursday afternoon, all visitors to the Turtle Back Zoo in West Orange can meet at the Alphabet Nursery for a storytelling hour.

Even adults seem to enjoy the stories of how certain animals found their way into the zoo, as told by Lillian Dieterle of Bloomfield.

Mrs. Dieterle also showed her audience a screech owl, two types of frogs, a prairie dog, a "flower" skunk, and an American kestrel, also known as a sparrow hawk.

"Now listen—I told you to roll over."

"How can you tell each other apart?"

"Now smile pretty like the opossum."

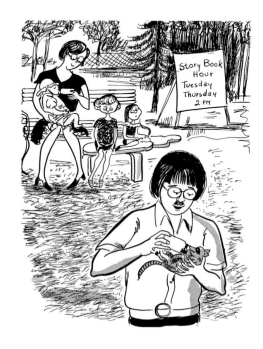

"I'm glad I don't have to diaper you too."

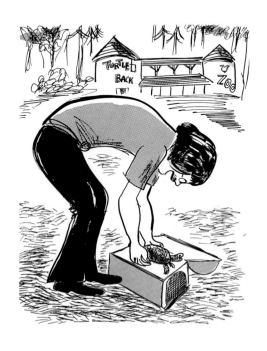

"You're not SUPPOSED to be a snapping turtle."

6. Grandparents Day

"A Grand Treat"
September 30, 1979

For the second time in this nation's history, Grandparents Day was observed.

To add to the day's festivities, Turtle Back Zoo in West Orange extended the celebration into a fun-filled week.

At the park's entrance, grandparents and grandchildren were admitted to the zoo free as guests of the Essex County Parks, Recreation, and Cultural Affairs group.

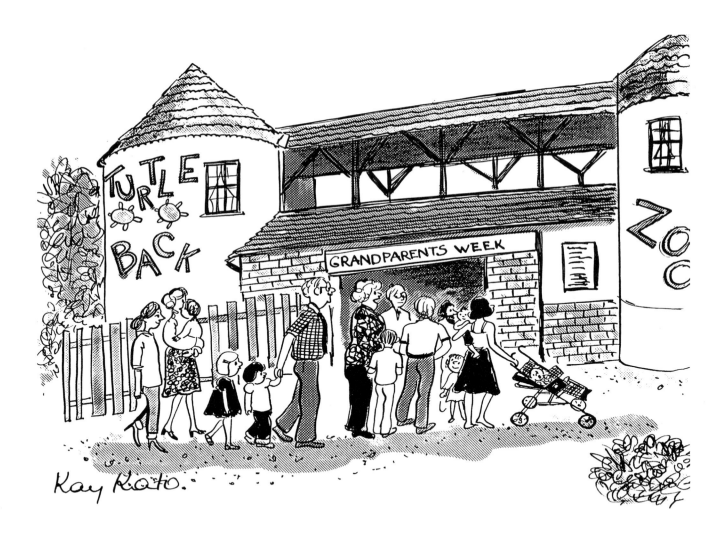

"There must be a special grandparent exhibit."

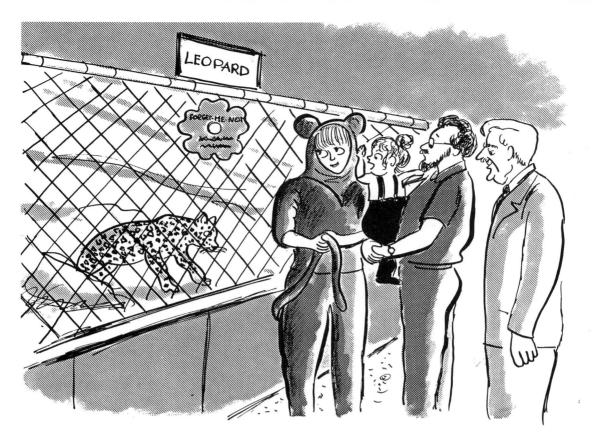

"This tiger is a phony—it's wearing lipstick."

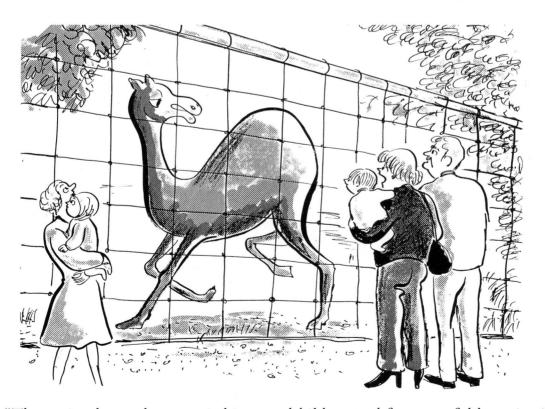

"That animal must have carried its grandchild around for an awful long time!"

7. Reptiles

"Cold-Blooded"

July 20, 1980

The third annual Reptile Exhibit is trying to give snakes a better image.

Jay Jason, the education lecturer at the facility, twists a rat snake around his neck, so called because it eats rats. A boa constrictor named Victor also is part of the show.

Jason said most people misunderstand snakes and have the idea all snakes are poisonous and are dangerous to people. This is not so, according to Jason.

"Look honey, aren't they something else?"

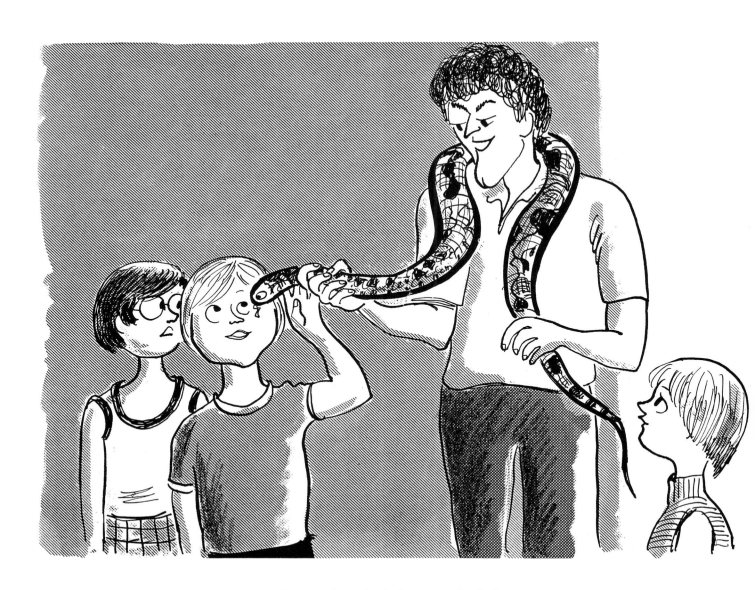

"See? They don't hurt anybody."

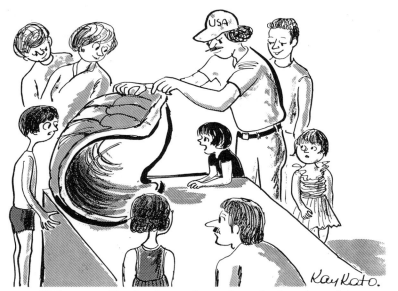

"Now we jiggle the sack and wait for something to happen."

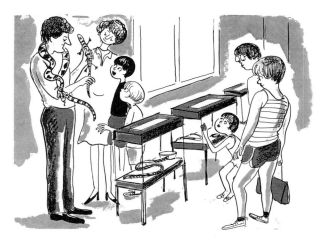

"I think he's going after his foot!"

"He's kind of cute, sort of."

8. Antique Cars

"Get A Horse"
April 24, 1983

Sixty antique cars, dating from 1905 to 1958, showed no signs of rust at the Antique Car Show.

At the end of the day, five judges were chosen to decide on the most beautiful car. A 1930 Reo won first prize.

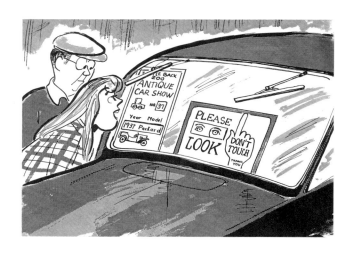

"That's incredible!"

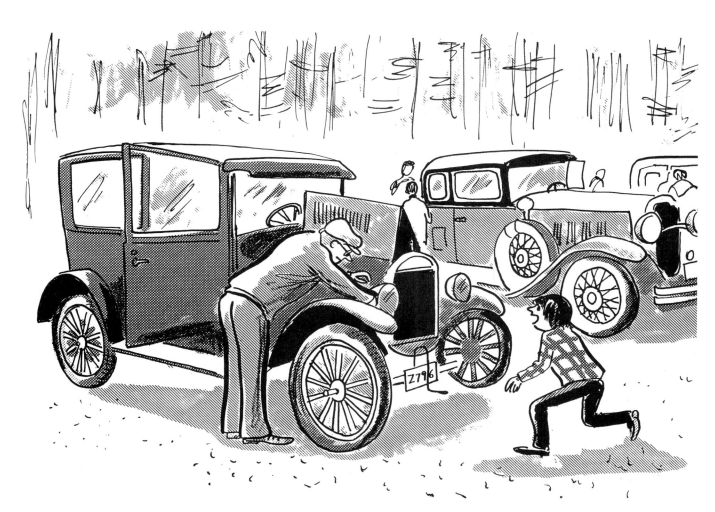

"Can I give you a crank-up?"

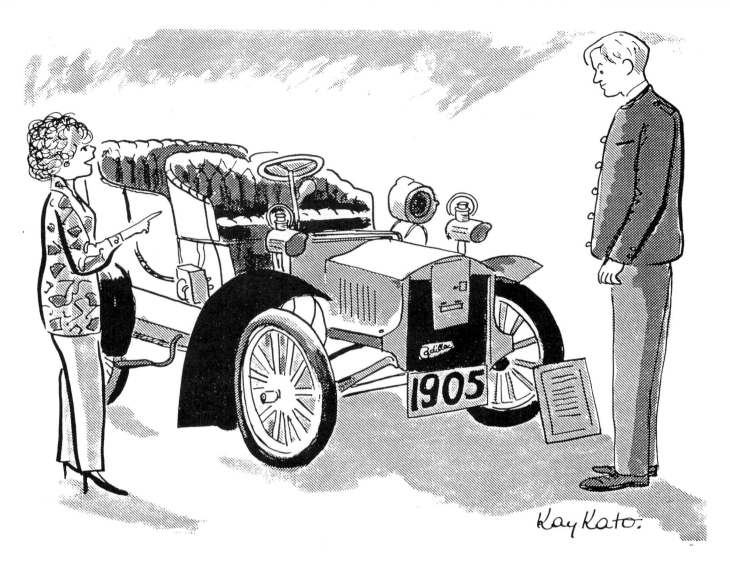

"Is this Caddy free?"

"Don't you watch enough birdies?"

9. Teddy Bears

"Bearable"
October 28, 1984

Teddy Bear lovers decided to bare their bears to a judging panel.

More than one hundred fifty owners, children, and adults, entered the contest, coinciding with Theodore Roosevelt's birthday, the spiritual father of the Teddy Bear.

Barbara Dyer of Turtle Back Zoo, "State Chair-bear of New Jersey," was in charge of the contest.

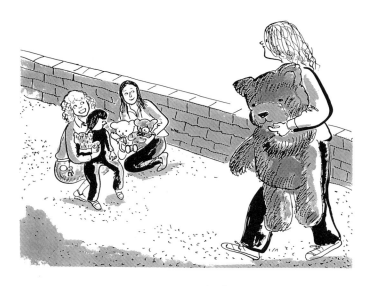

"Is that a grizzly bear?"

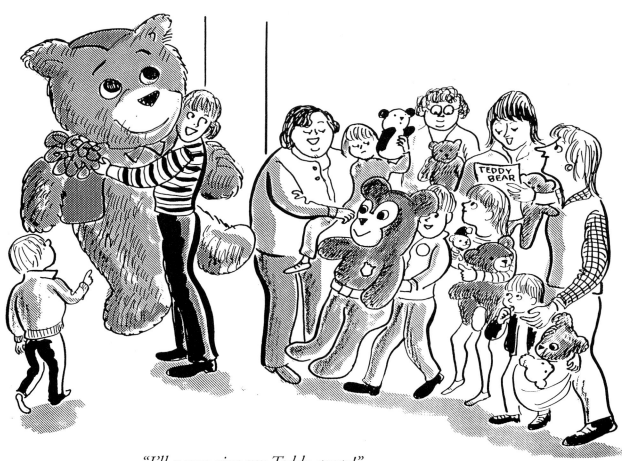

"I'll never give my Teddy away!"

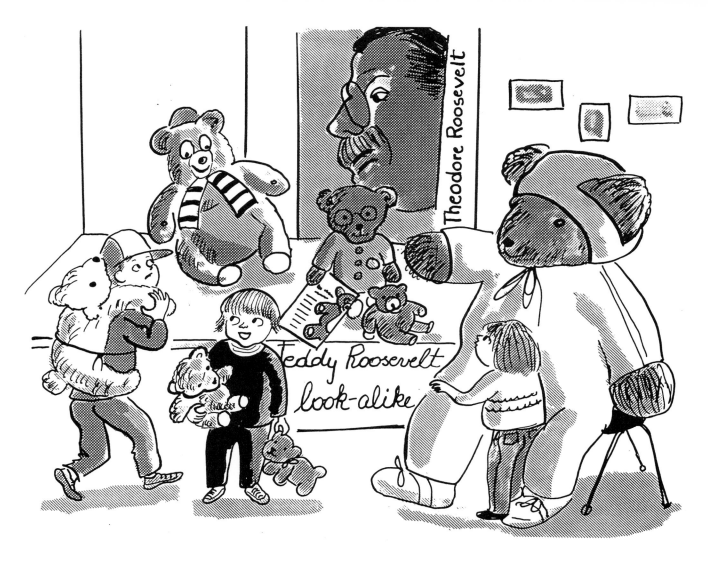

"He's giving you a bear hug."

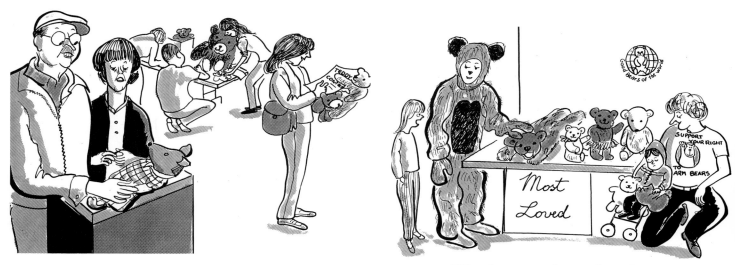

"We should have given him a bath."

"You leave my bear alone!"

"Bear Necessities"
March 3, 1985

"Good Bears of the World," an international organization with headquarters in Hawaii, feels that cute and cuddly Teddy Bears are what every child should have, especially the sick and abused child.

The zoo sent out flyers asking people to donate Teddy Bears for needy children, and so far the response has been great.

The zoo distributed some of the bears at the Saint Barnabas Medical Center in Livingston, where children's faces were quickly illuminated with smiles.

"Here are your bear essentials."

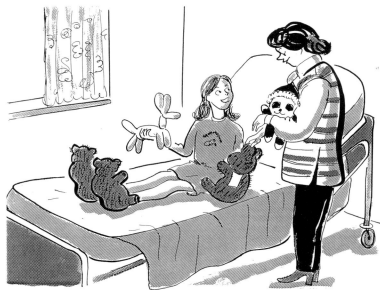

"I'm building a collection."

"Gosh, I thought I was too old for this stuff!"

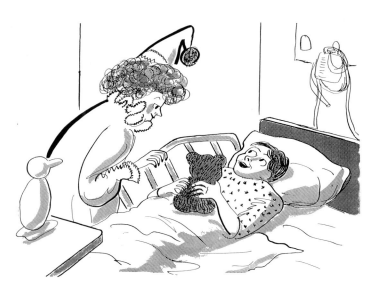

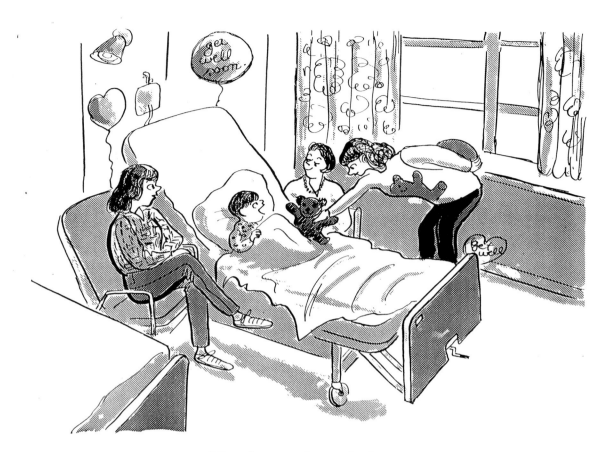

"Can he stay the night?"

"Here's a little friend for you."

11. Art Alfresco

"For Art's Sake"
July 14, 1985

Essex County residents, sixty and older, exhibited their artworks which were judged in two categories, professional and nonprofessional. The categories judged were painting, drawings, and graphics.

Artworks winning the first three places in each category will be sent to the Trenton Museum.

"We haven't been to the zoo in years!"

"This does not look like my mother!"

"Well, it's certainly interesting."

26

"Mom, you did this? We could have saved a fortune on decorating!"

"The one on the left will go great in the living room."

12. Zoo-ology

"Zoo-ology"
November 17, 1985

More than six hundred species of animals are gathered for children and adults to appreciate.

Children had fun feeding the llamas with special food available at the zoo. They also enjoyed watching a zoo volunteer feed the camels.

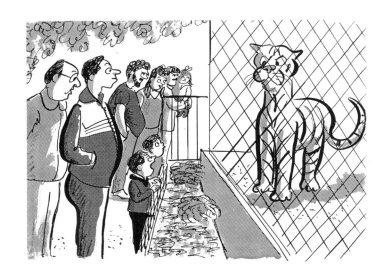

"Hi, Buster!"

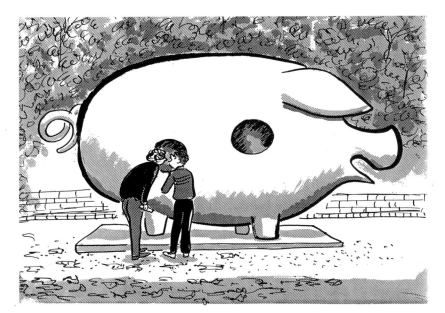

"Can I have a piggybank this size?"

"Watch your fingers!"

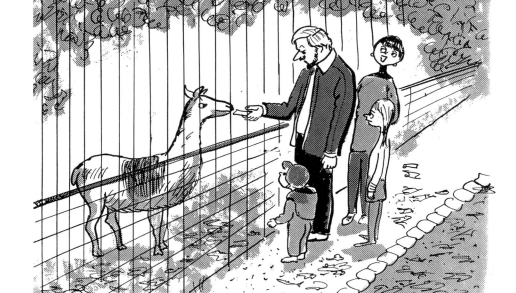

"Be a good camel!"

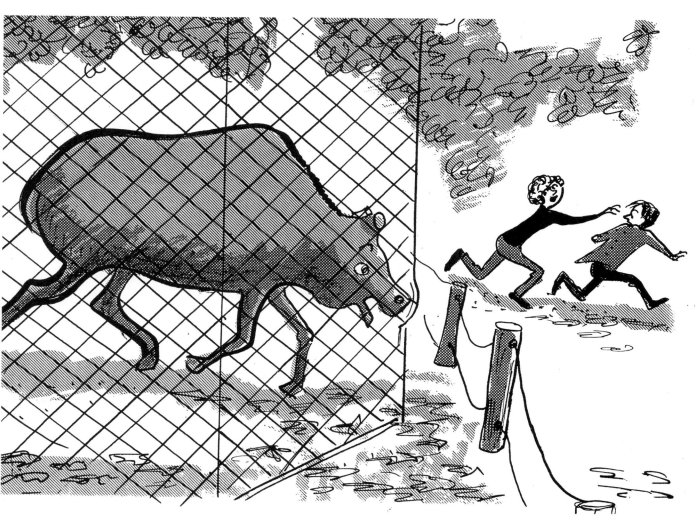

"He's mad!"

13. Rhino

Save the Rhino
June 28, 1987

The black rhinoceros, which is quickly becoming extinct, was the subject of a special program.

The species, which lives on the ranges of Africa, numbered approximately 20,000 in 1970. Today, only 370 remain.

The rhinoceros are killed by poachers who hunt the animals' horns.

The zoo constructed a wire-and-paper rhino and played a game with guests.

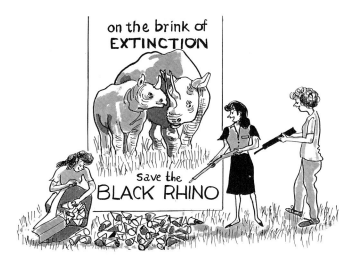

"Your horns or your life."

"Don't worry, it won't hurt you."

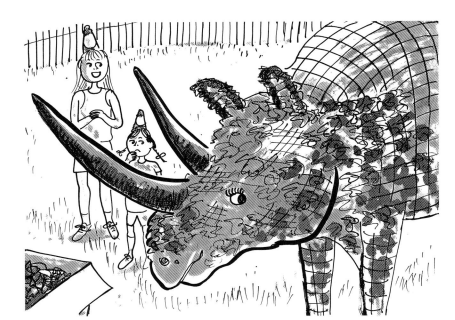

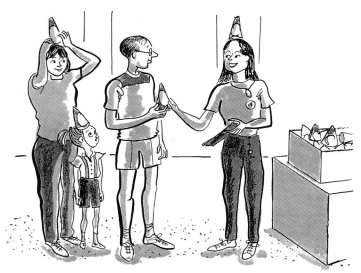

"The hat represents the rhino's horn."

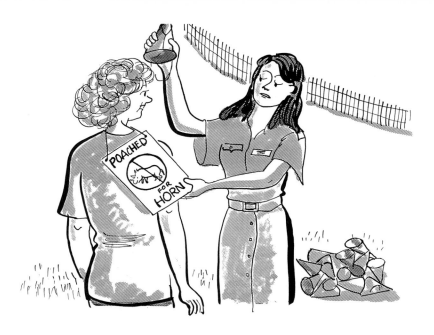

"Gotcha!"

"Can I go for a ride, Mommy?"

14. Docents

"Zoo-logistics"
July 9, 1989

The Docent Organization sponsored the first zoo summer fest.

The organization evolved about five years ago to educate people about animals. The volunteers are sent through a twelve-week training session which meets once a week.

Group tours of the zoo are given throughout the year, and children can feed or pet the animals. In the summer, "Night Move," a tour, is given with flashlights.

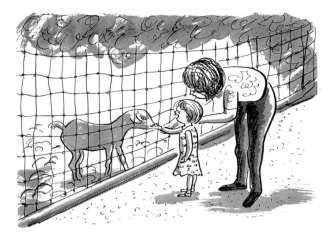

"Mr. Goat, you know I need my fingers!"

"Look honey, you two look just alike!"

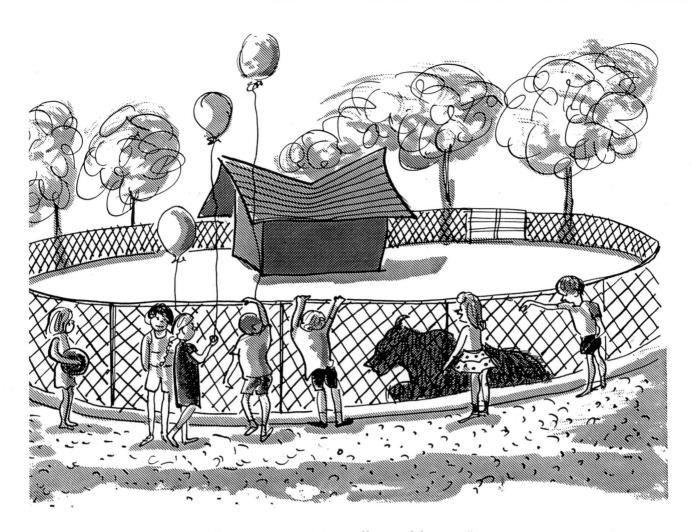

"Hey, Jimmy! He smells just like you!"

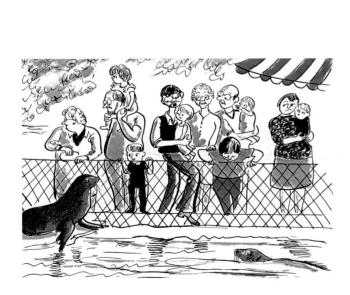

"I don't understand what the attraction is."

"He looks like he could use a V-8!"

15. Animal Fun

"Animal Fun"
July 22, 1990

Once only a petting zoo, the Turtle Back Zoo has grown to a regular zoological garden, and now needs one hundred volunteer zoo keepers, or "docents," to maintain the grounds and look after the animals.

While two aged sea lions are still the zoo's most popular tenants, a new "Wolf House," with two male and two female wolves, and one hundred newly hatched turtles also attract young visitors' attention.

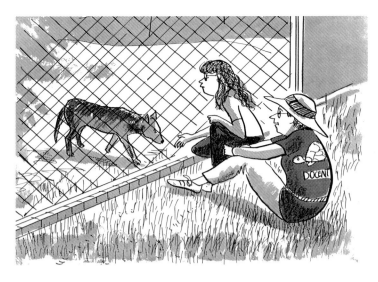

"Watch your fingers!"

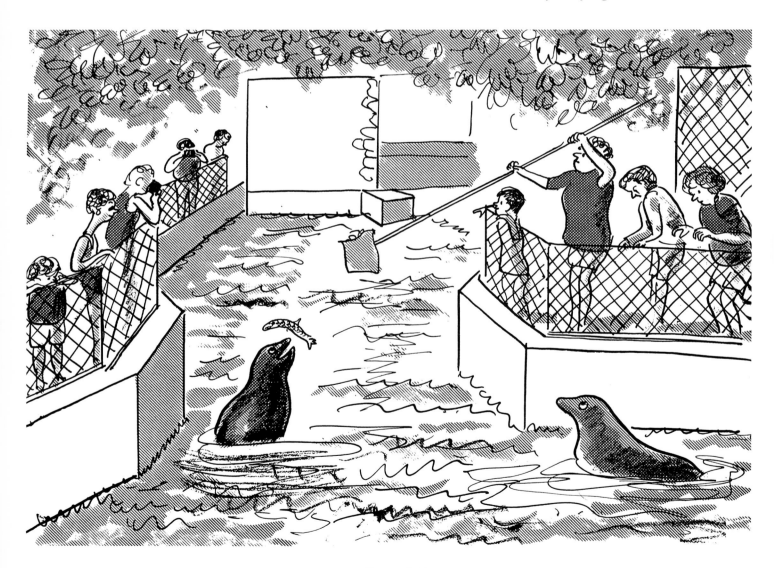

"Lunch!"

"Turtle eggs? Oh, gross!"

"Don't worry, Mrs. Deer, he won't hurt your fawn!"

"Hey, like I can dig the feathers, man!"

16. Breakfast with the Animals

"Zoo Stories"
October 4, 1992

Visitors to the Turtle Back Zoo were invited to "Breakfast with the Animals," courtesy of the Zoo and the New Jersey Zoological Society's Adopt an Animal Program.

The humans actually enjoyed their own continental breakfast, but they came early to watch the animals being fed, which usually takes place early in the morning. Helping the animal keepers were docents, volunteers, and several young women majoring in science.

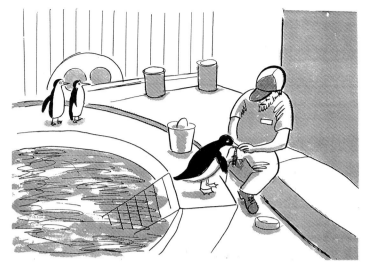

"If he survives, we'll take the plunge."

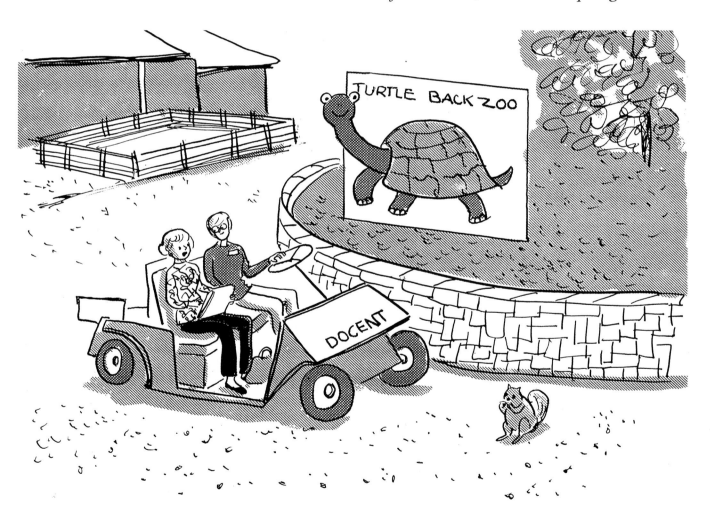

"No need to feed the squirrel, Dear."

"I should eat as well as the zebu."

"Show a little pride, peacock!"

17. Winter Workshop

"Nature Crafts"
December 19, 1993

The sixth annual Winter Workshop for children was held. During the two-day event, the docents helped the children make crafts for the zoo animals. Among the items crafted were food chains and bird feeders. A new feature at this year's workshop was "Tracks and Prints," in which attendees learned to identify animal foot-prints. Proceeds from a wishing well were used to buy Christmas presents for the zoo animals.

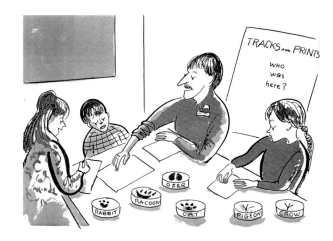

Right at your fingertips.

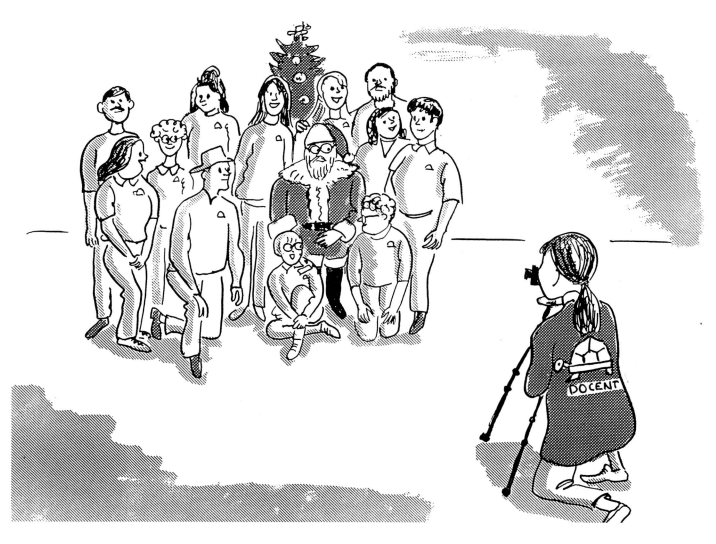

"Say cheese."

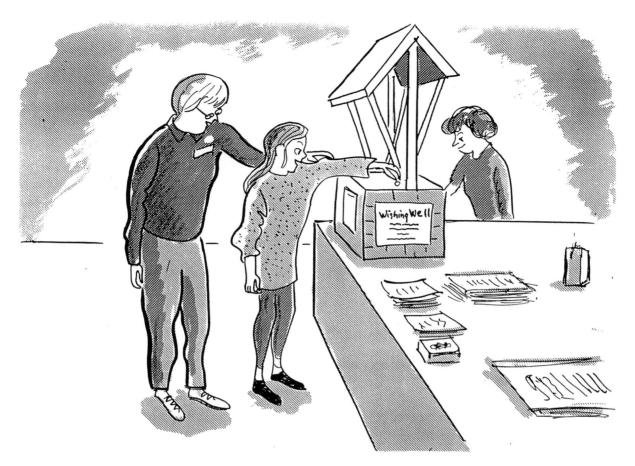

"Make a wish."

Stringing along.

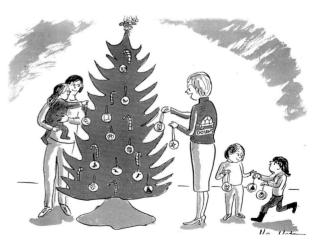

Hanging around.

18. Dental Health

"Brusha, Brusha"
April 16, 1995

The Turtle Back Zoo made its contributions to children's health by allowing kids free into the zoo, with a catch. They had to present certificates indicating they had visited their dentists during Dental Health Month.

For their efforts, the children were treated to a magic show, exhibits of such pets as rabbits, mice, and beavers. There was Captain Supertooth to encourage frequent brushing. And there were games for all.

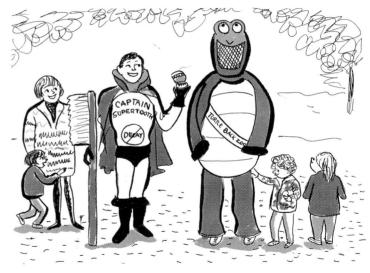

"Is the captain holding the turtle's fake teeth?"

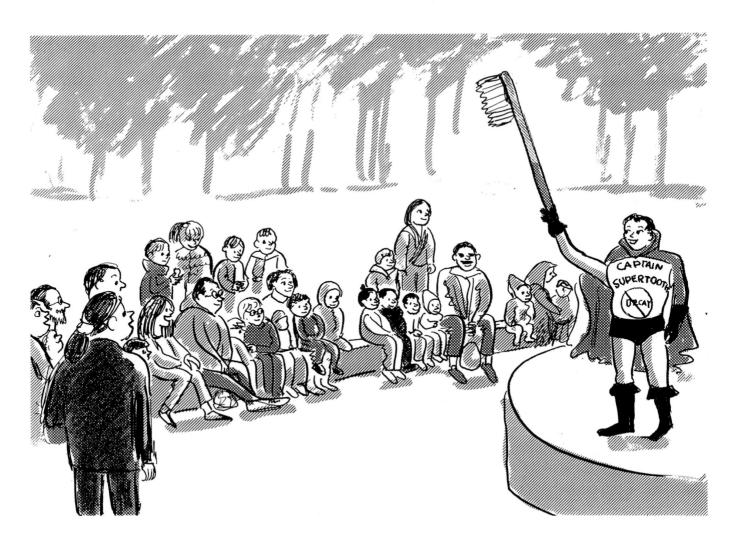

"No, no, a small toothbrush will do!"

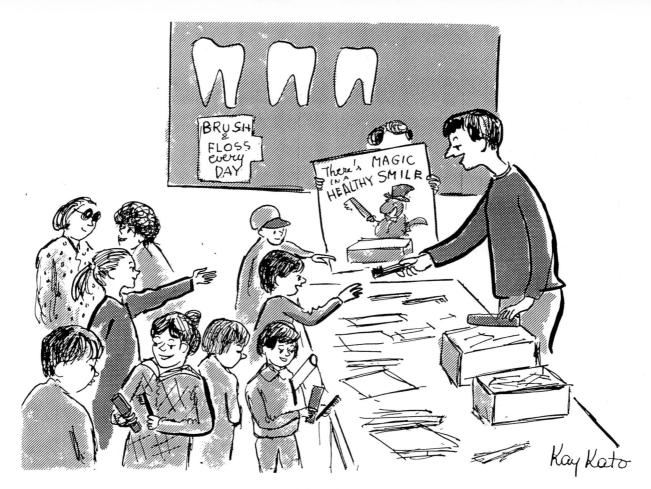

"I want my toothbrush so I can go home."

"This is the way I floss my teeth . . ."

"You never brushed your bunny's teeth?"

Chapter 2

1. June 13, 1965 Outdoor Art Show
2. December 19, 1965 Christmas Tree Decorating
3. July 24, 1966 Model Yachts
4. July 31, 1966 Concert Under the Stars
5. September 8, 1966 Pic-nic
6. July 9, 1967 Archery
7. April 14, 1968 Easter Egg Roll
8. November 9, 1969 Art Class
9. December 21, 1969 Ice Skating with Santa
10. June 7, 1971 Folk Festival
11. August 6, 1972 Seniors Exercise
12. June 24, 1973 Softball
13. June 30, 1974 Bikes in the Park
14. July 7, 1974 Folk Music
15. July 6, 1975 Dog Obedience
16. July 13, 1975 Playgrounds
17. August 31, 1975 Summer Jamboree
18. September 7, 1975 Senior Events
19. April 18, 1976 Rose Pruning
20. August 22, 1976 Petanque
21. July 24, 1977 Kids Fishing
22. November 13, 1977 Dinosaur Footprints
23. July 24, 1978 Concert in the Park
24. July 30, 1978 Girl Scout Camp
25. September 10, 1978 Lawn Bowling
26. September 17, 1978 Circus
27. September 24, 1978 Senior Broadway Show
28. October 1, 1978 Clowns on The Green
29. November 26, 1978 Soccer
30. December 17, 1978 Dinosaur Park
31. July 8, 1979 Boating
32. May 4, 1980 Cherry Blossoms
33. May 18, 1980 Plant Sale
34. June 29, 1980 School Carnival
35. June 28, 1981 Golf
36. July 18, 1982 Tricentennial
37. October 31, 1982 Tennis Complex
38. August 7, 1983 Softball Game
39. August 19, 1984 Civic Band Concert
40. July 7, 1985 Folk Festival
41. July 21, 1985 Circus
42. September 1, 1985 African Drummers
43. June 15, 1986 Bike-a-thon
44. July 27, 1986 Pie Eating
45. August 31, 1986 Indian Independence Day
46. September 14, 1986 Haitian Festival
47. June 21, 1987 Court Judges Play Softball
48. August 30, 1987 4-H Fair
49. May 27, 1990 British Faire
50. July 15, 1990 Met in the Park
51. August 4, 1991 4-H Fair Youth Festival
52. August 11, 1991 Day Camp
53. November 8, 1992 History and Heritage Fair
54. October 3, 1993 Arts and Crafts
55. July 23, 1995 Encampment

Chapter 2 Parks

1. Art

"Outdoor Art Show"
(Washington Park, Newark)
June 13, 1965

The annual outdoor art show in Newark's Washington Park is becoming almost as traditional as the one in New York's Washington Square. But the New Jersey exhibition is quite different from the one across the river.

Ours is run by the Art Directors Club of New Jersey.

Among the people I spoke with on my visits to the show were Joseph Golinko, president of the Art Directors' Club; Otto Storch of Wayne, art director for *McCall's Magazine*; Mr. and Mrs. Lawrence Mihlon of Little Silver—he works for Esso publications; and Kathy Lesien, age ten, of Harrison, who had spotted the tent on her way to The Newark Museum.

"Seems to me folks should expect a draft or two at an outdoor show."

"I still say there's nothing that'll grab their attention like a pretty girl in a bathing suit."

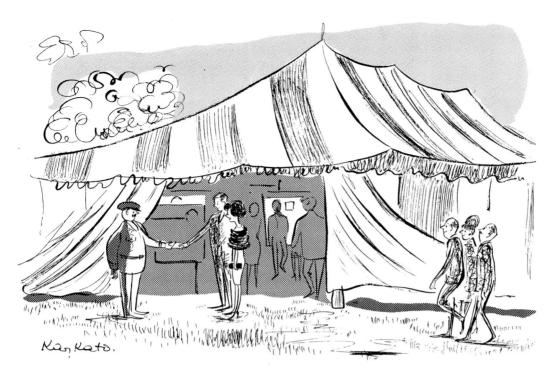

"This is almost as nice as the tent on the Governor's lawn."

2. Christmas Tree Decorating

"Artist Branches Out"
(Military Park, Newark)
December 19, 1965

Decorating a holiday home can be almost as hectic as it is exciting, especially with less than a week to go before Christmas.

Decorating a city is an even bigger job, and one that is usually tackled well in advance to provide a festive atmosphere for seasonal shopping.

I found myself on the twenty-first floor of the Military Park Building for a bird's eye view of the city's official Christmas tree.

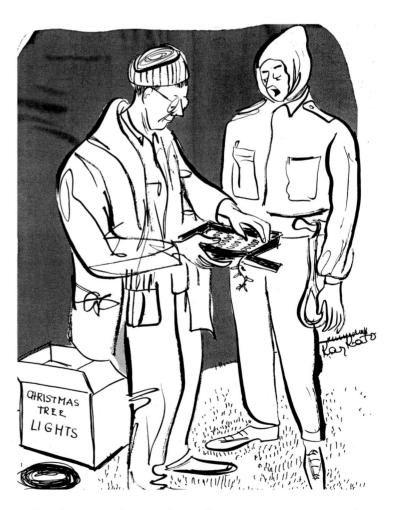

"Before you do anything drastic, Harry, remember the blackout."

"Did I hear somebody yell 'Timber'?"

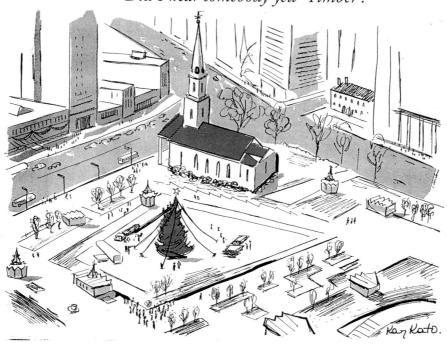

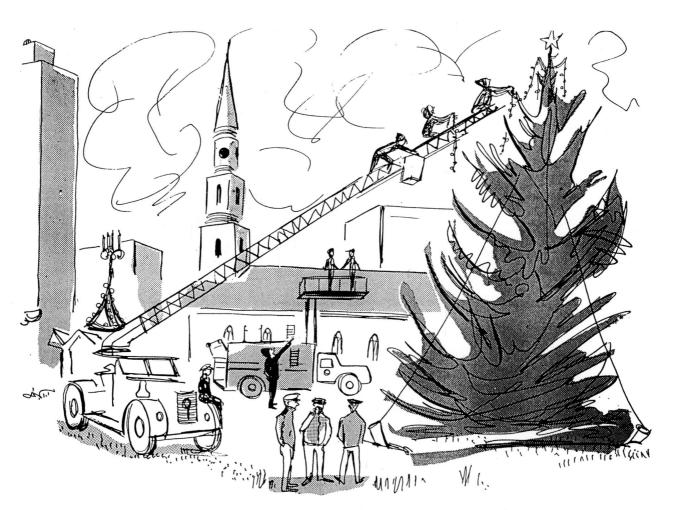

"I said a little more to the right. Who do you think you are, the three wise men?"

3. Model Yachts

"A Yacht is a Yacht"
(Verona Park)
July 24, 1966

You don't have to be a millionaire to own and race a yacht in New Jersey waters, as I discovered last week when I visited the Montclair Model Yacht Club in Verona.

There, on Verona Lake, members gather every Sunday morning from 9:00 a.m. to 12:00 p.m. to race their model fifty-pound yachts.

The miniature yachts, scaled down models of the real things, are built by club members. Making one from blueprints in a member's leisure time generally takes about a year.

One yacht I spotted was made completely of fiberglass.

Among those I talked with were three club officers—Commodore Tony Alworth of Caldwell, Vice Commodore Angus Scott-Fleming of Upper Montclair, and Secretary Jerry Dunham of Maplewood. I also chatted with Mrs. Louis Dunham, the secretary's mother, and Mrs. Elizabeth Boyle of Verona.

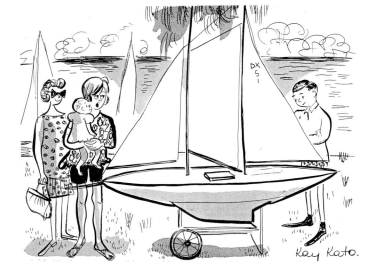

"Would you reach below, Ernie, and get the diaper bag?"

"Stop pouting, Alice. I promise I'll fix the back door the minute we get home."

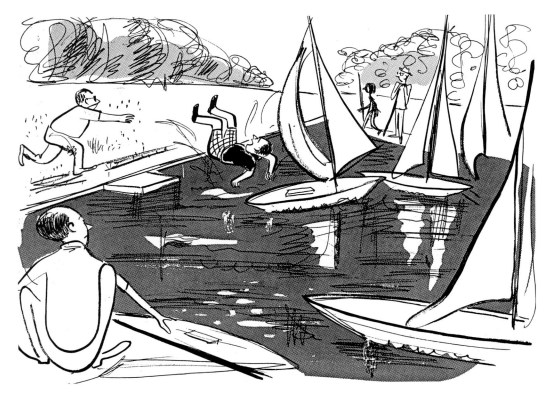

"There goes Harrison, disqualified again."

4. Concert Under the Stars

"Program Notes"
(Branch Brook Park)
July 31, 1966

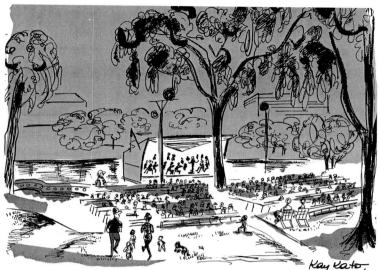

"We've got to convince them somehow that this is more fun than Ed Sullivan."

Music under the stars on a summer night continues to be a popular attraction for New Jersey families fortunate enough to find it within driving distance.

In Branch Brook Park, Newark, a mostly adult audience turned out for a Wednesday night concert by the Newark Symphony Orchestra, conducted by Alfredo Silipigni of West Orange and highlighted by experts from Puccini's opera, *Tosca*.

Among those I talked with were soprano Linda Heimall of Union, tenor Boris Cristaldi of Bloomfield, and trumpeter John Borbone of Belleville.

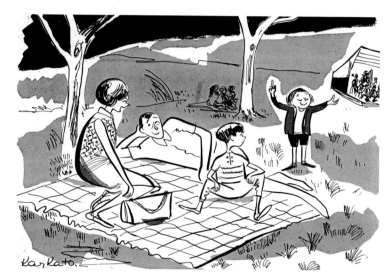

"He'll either be a symphony conductor or a traffic cop."

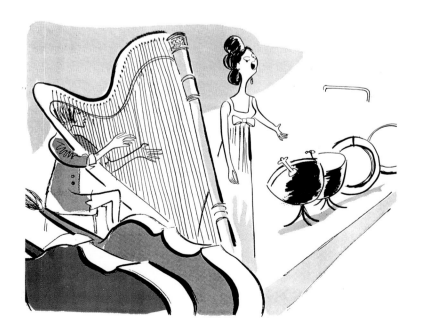

"Tell them to hold it, Judy. I just swallowed a bee."

5. Pic-nic

"Fun For All Verona"
(Verona Park)
September 18, 1966

For more than a decade, picnicking in Verona has been a community affair.

The festivities included personal greetings from Verona Mayor Hobert B. Howe.

One contest was the "Diaper Derby," a race run—or rather crawled—by children six to ten months old. Mothers tried with varying degrees of success to coax their offspring across the finish line, but some entrants stubbornly refused to budge. The winner was eleven-month-old Tony Ciccotti, now thirty-four years old!

"I'm tempted to spike his baby food. It might make him crawl faster."

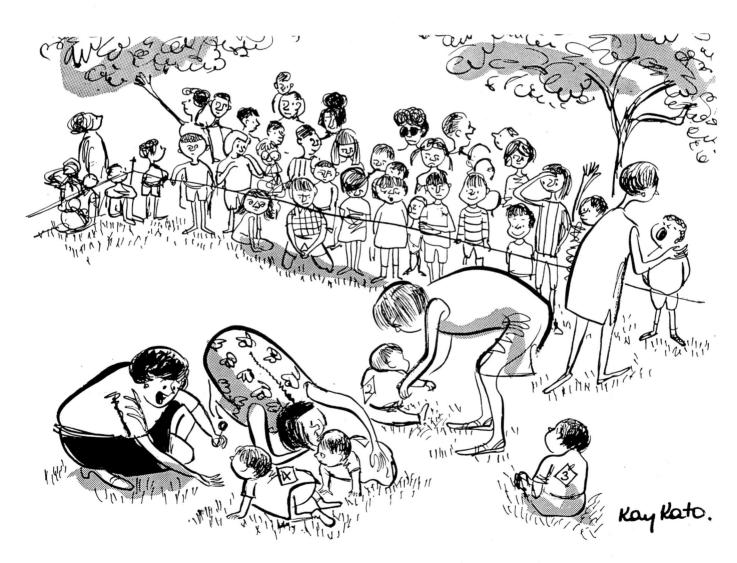

"Just this once, Oliver, crawl forwards—please?"

6. Archery

"On Target!"

(Verona Park)

July 9, 1967

The archery classes held three times a week by the Essex County Park Commission really hit the spot for youngsters between eight and fifteen years of age.

I visited one of the classes, held in Verona Park.

The targets were placed fifteen and twenty yards away. Students retrieved their own arrows, each with its own assigned color.

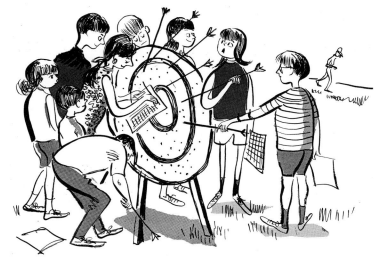

"Well, it hit the target, didn't it?"

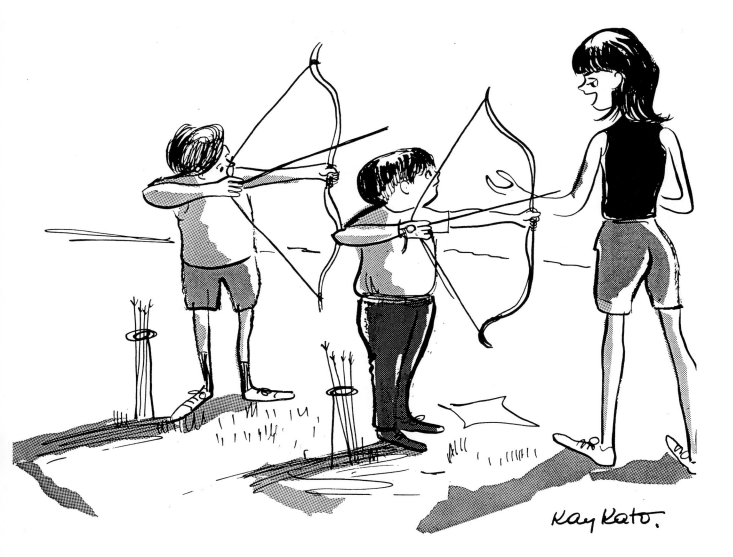

"Watch it, Buster, that thing's loaded."

7. Easter Egg Roll

"Easter Egg Roll"
(Cedar Grove)
April 14, 1968

I watched as youngsters from pre-school through second grade hunted Easter eggs in Cedar Grove Community Park, sponsored by the Cedar Grove Women's Club.

The highlight of the morning was a visit by the Easter Bunny.

Some of the children scooped up enough eggs to satisfy their appetites, then sat down beneath a tree and ate them!

In all, seventy-seven dozen eggs were colored and brought to the park—all by the faithful mothers.

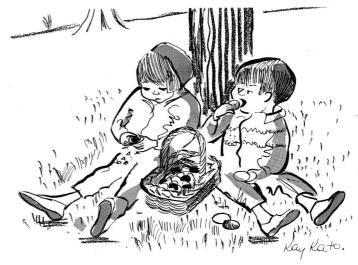

"This is a great system—you peel 'em, I eat 'em."

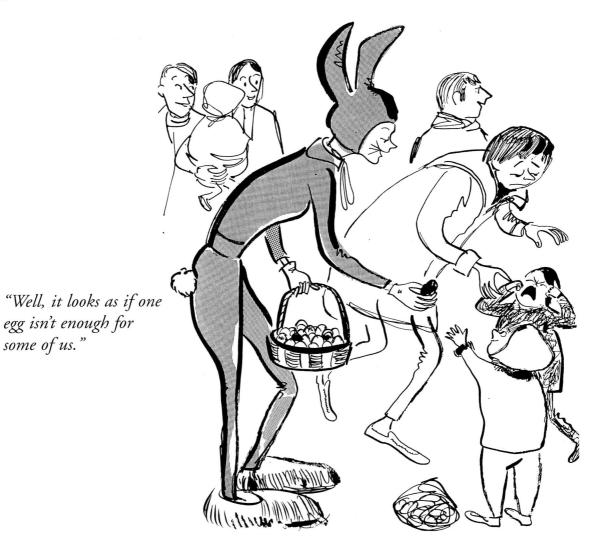

"Well, it looks as if one egg isn't enough for some of us."

8. Art Class

"A Morning of Art"
(Edgemont Park, Montclair)
November 9, 1969

Each Thursday morning an ambitious group of art students bring their easels and paintboxes to a little lake in Edgemont Park, Montclair.

They are students of landscape painting at the Montclair Adult School.

"The weeping willow seemed to be the favorite subject for the students."

Most of the students were beginners. They were told by the teacher they were developing a hobby that could remain with them all their life.

"Here, nice duckie, duckie, duckie."

"It's pretty, but is it art?"

"Since when did you become an art critic?"

9. Ice Skating with Santa

"Having an Ice Time"
(Branch Brook Park)
December 21, 1969

I visited the Branch Brook Park Ice Center, among the largest in the state, and found it bigger and better than ever.

I found the music blaring and the skaters twirling about the ice and enjoying themselves.

The tallest Santa Claus I had ever seen made an appearance with the youngsters on the ice. A photographer snapped pictures of the event.

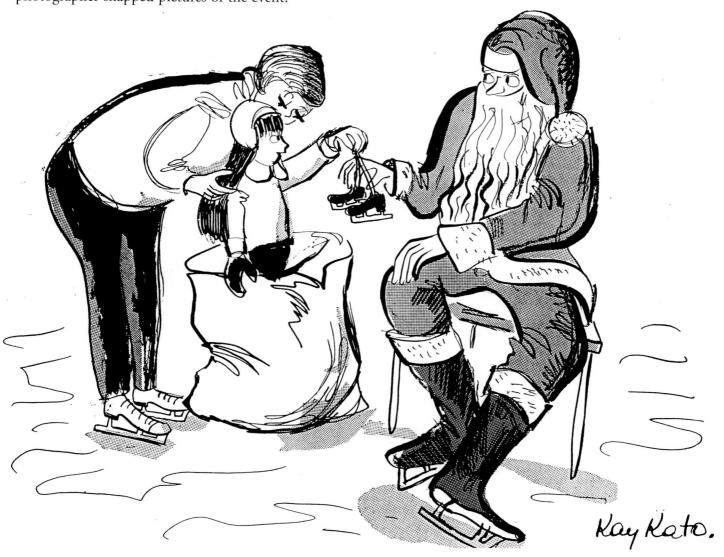

Kay Kato.

"Thanks Santa, but what I really wanted was a catcher's mitt."

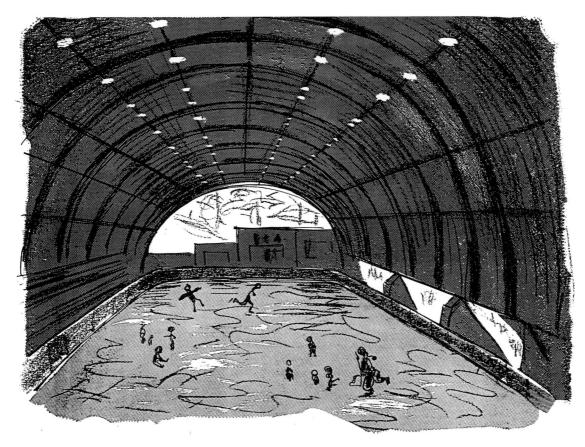

A long look at a skater's paradise.

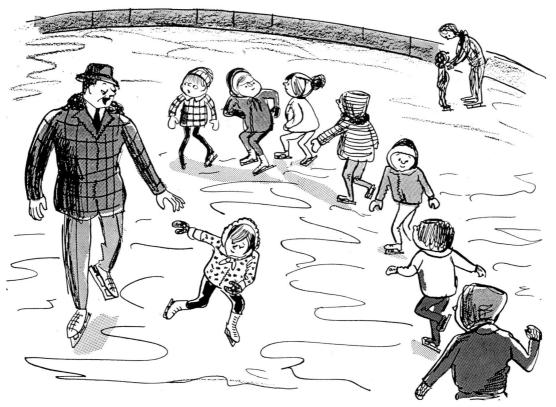

"Stop showing off and making me look bad."

10. Folk Festival

"Folk Fun Festival"
(Verona Park)
June 27, 1971

I, always on the lookout for a subject which combined human interest with a dash of humor, last week visited the fourth annual folk festival in Verona Park, sponsored by the Verona Interfaith Youth Group.

The contestants came from many surrounding towns: Mendham, Morristown, Wayne, Roselle Park, West Orange, Montclair, East Orange, and Verona.

No electric guitars were allowed and preference was given to original songs, with titles like "Prohibition Poppers," and "Innocence on a Dissertation."

"Come with me to the folk festival and we will make beautiful music, together."

"Of course boys can wear flowers in their hair! Anyway, it'll go nice with your braids."

"Never mind the words, just hum along until we get to the last verse, then give a peace symbol and we'll split."

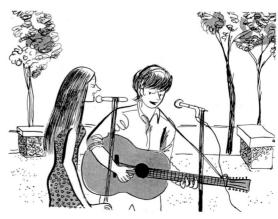

11. Seniors Exercise

"Instant Exercise"
(Belleville)
August 6, 1972

I visited the Senior Citizen's Building in Belleville where I found sixty, seventy, and even eighty-year-olds doing exercises.

The exercises were isometrics—the kind anybody can do anytime and anywhere.

The principle of isometrics is to pit a muscle against an immobile object.

Senior citizens were doing isometrics under the guidance of Ben Schaffer of Livingston.

One of the favorite and most important were the facial exercises. These help keep the face looking young and provided some fun for the senior citizens who were told to pucker up their lips for a kiss.

One senior citizen reported that the isometric exercises helped his backache.

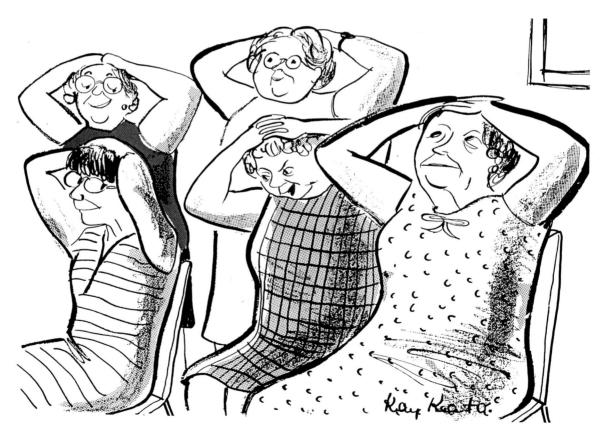

"Either my arms got shorter or my head got bigger, but this is a roughie."

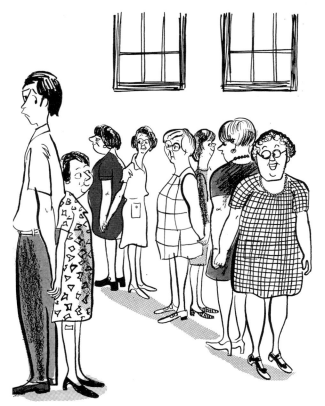

"This exercise is right up your alley, Mary."

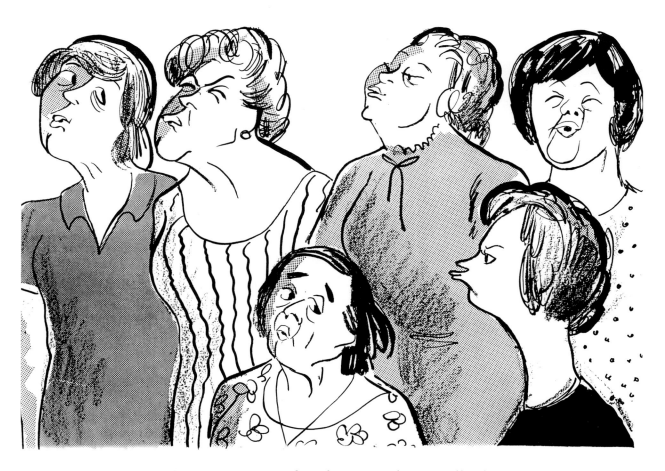

"You must remember this . . . A kiss is still a kiss."

12. Softball

"Women on Deck"
(Verona Park)
June 24, 1973

The Verona Recreation Department has begun sponsoring women's softball games for the summer.

In a recent match between the Verona softball team and an independent team from Orange, many members of the "visiting" team were of high school age. The home team consisted, on the other hand, of "older" women in their late twenties and early thirties. Many were mothers who brought their children along for moral support.

The ballplayers have no uniforms, and so participated in cutoff jeans, midriff tops, sneakers and socks, occasionally topped by a headful of rollers.

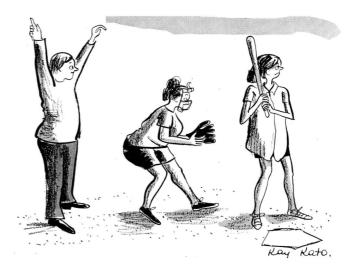

"Come on, Sheila, right over the plate! This Jane couldn't hit a Mack truck!"

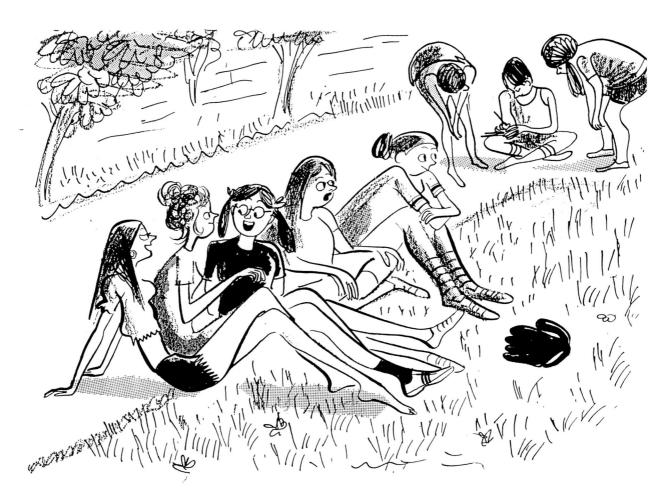

"We'll beat 'em. Half the other team has to pick up their kids at school in fifteen minutes."

13. Bikes in the Park

"Bike 'N' Park"
(Branch Brook Park)
June 30, 1974

About one hundred people, half each from New York and New Jersey, took part in a bicycle tour of Branch Brook Park in Newark.

The New York bicyclists joined the New Jersey group in front of Sacred Heart Cathedral in Newark.

The bike tour was co-sponsored by the Friends of Central Park and the Friends of Branch Brook Park.

The group also heard about the Robert E. Ballantine Gateway to the park, the Prudential lions and the Tiffany silver factory.

The tour visited the Syndenham House, the oldest home in Newark, built in 1712.

The bicycle tour covered approximately fifteen miles.

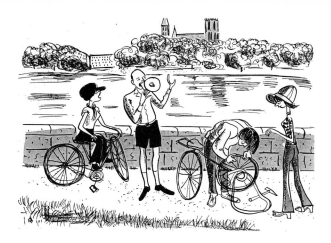

"While Jerry changes his tire, let's look across the lake at Sacred Heart Cathedral. . . ."

"It's got as much class as Central Park, and almost as much suspense!"

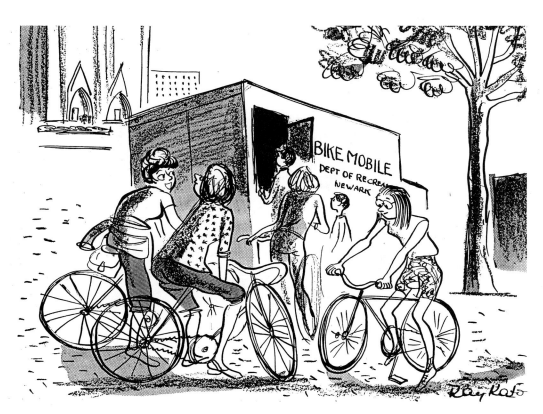

"Sure I can ride a bicycle—what's to learn!"

14. Folk Music

"A Day in June"
(Eagle Rock)
July 7, 1974

The June Day celebration at Eagle Rock Reservation in West Orange, sponsored jointly by the Folk Music Society of Northern New Jersey and the Essex County Park Commission, has grown steadily in popularity since its inception in 1970.

In the workshops musicians demonstrated unusual instruments and styles, encouraging audience participation.

Some of the rarer traditional instruments on display included the concertina, Irish pipes, African thumb piano, autoharp, mandolin, hammered dulcimer, and Appalachian dulcimer.

Another trio used a guitar, mouth harmonica, and "washtub bass." The last was made from a washtub, a broomstick, and naval wire, and it is best played by someone wearing gloves.

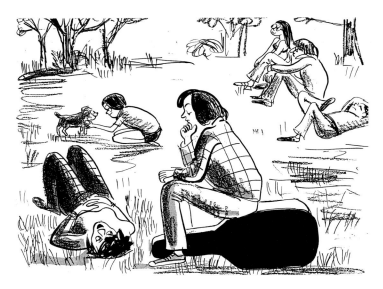

"This is my way of getting down to the grassroots."

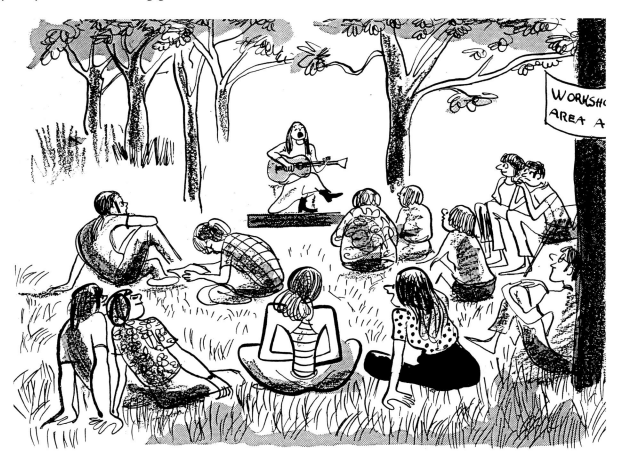

"You think it's easy singing the blues on a $500 guitar?"

15. Dog Obedience

"Summa Cum Doggie"
(Egdemont Park, Montclair)
July 6, 1975

A class in dog obedience was held by the Montclair Young Men's Christian Association (YMCA) at Edgemont Park in Montclair.

They were taught to perform a "solid" jump over a hurdle. But the dogs weren't the only ones jumping: their owners had to jump the hurdles with them.

At the end of the sessions, certificates were distributed. One dog not only took a close look at his certificate, but also took a bite out of it.

". . . And don't look at me with those big, sad eyes."

"He's disappointed in his bad grade in heeling."

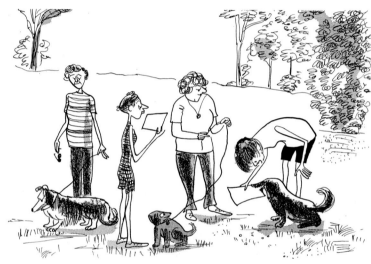

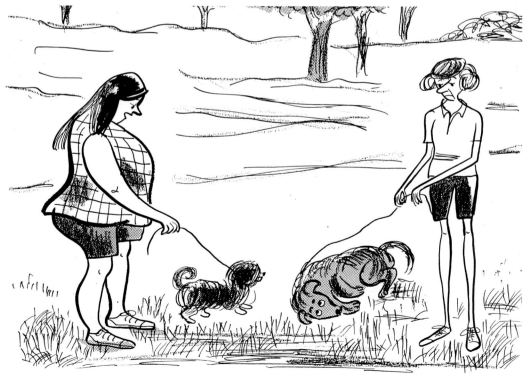

"My dog won't lay down because he has a mind of his own."

16. Playgrounds

"City Summering"
(Essex County Park)
July 13, 1975

The Essex County Park Commission has created summer playground programs for inner-city youngsters to provide them with much-needed open space, fresh air, a sense of achievement, and a feeling of belonging.

One playground apparatus that I found interesting was called a "Moonhouse," on which the children climbed up and through. Experienced and talented recreation leaders and specialists supervised the children on this toy.

"Someone told me if I do this every day for about five years I'll grow faster."

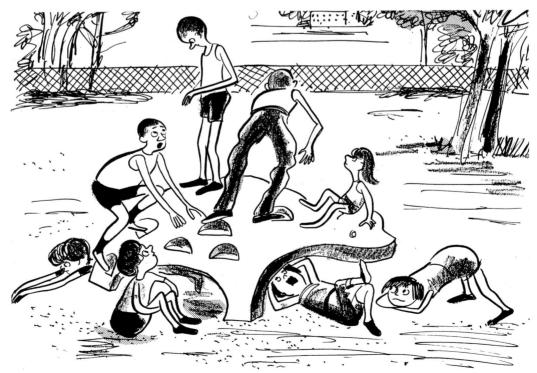

"I can't play on this one. I'm scared of heights."

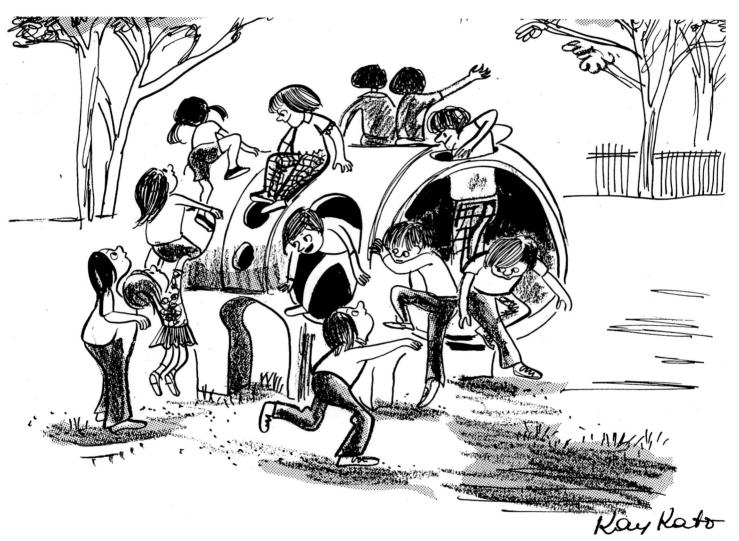

"I think my brother got lost in this thing."

17. Summer Jamboree

"Joyful Jamboree"
(Garfield Park, Maplewood)
August 31, 1975

Some two thousand youngsters converged on Garfield Park in Maplewood.

The youngsters were entertained by rock bands, African dancers, a puppet show, and a clown, who doubled as master of ceremonies.

The Ishangi Dancers, a family act from Africa, performed native dances to the accompaniment of pulsating drums.

Ronald McDonald of television fame asked for volunteers for paddle ball.

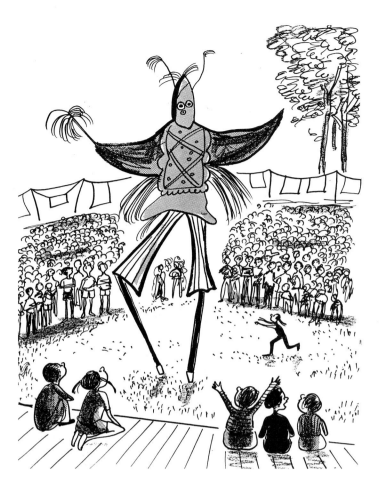

"You should see him when he puts his costume on."

"Look at it this way, at least you're getting practice for the winter."

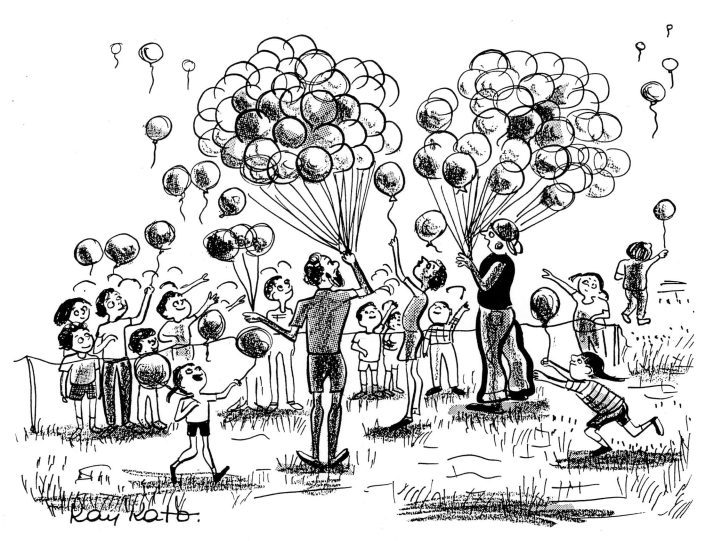

"I guess we're using balloons because they're cheaper than pigeons."

18. Senior Events

"Old-Timers Day"

(Verona Park)

September 7, 1975

A day of fishing, music, and general relaxation was recently held for senior citizens by the Essex County Board of Chosen Freeholders, the county's Park Commission, and the Office on Aging at Verona Park in Verona.

After welcoming remarks from Bernard J. Gallagher, director of the Office on Aging, the fishing contest began.

Afterwards, the Nutley Senior Citizens Band took to the stage. The band, consisting of trombone, trumpet, saxophone, violin, piano, bass, and drum, was composed of former professional musicians. The musicians, whose average age was eighty, played entirely by ear.

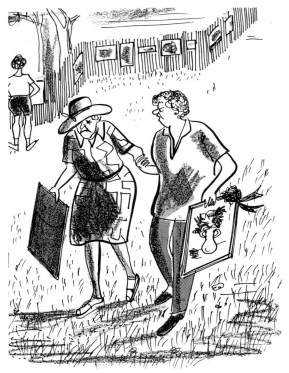

"Look at it this way, the first painting Goya did was probably rejected too."

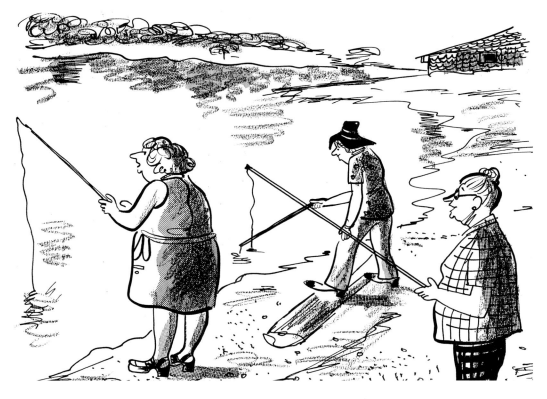

"A shark really was on my line, but he got away."

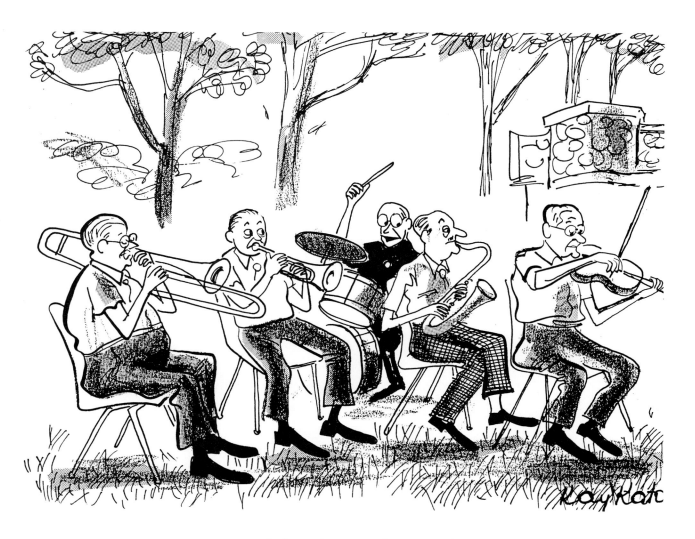

"I love this new disco sound."

19. Rose Pruning

"Everything's Rosy"
(Brookdale Park)
April 18, 1976

The finer points of gardening were the topic of discussion when the North Jersey Rose Society presented its rose pruning demonstration at Brookdale Park in Bloomfield.

The society suggests pruning shears with both blades curved for rose care, rather than flat or anvil shears, which mash the soft pith.

In order to do a good pruning job, the novice was instructed to cut all dead, diseased, and damaged branches, making sure to make the cuts just above the outside leaf bud.

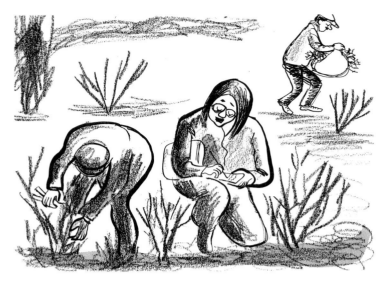

"Are you sure that's a rose plant?"

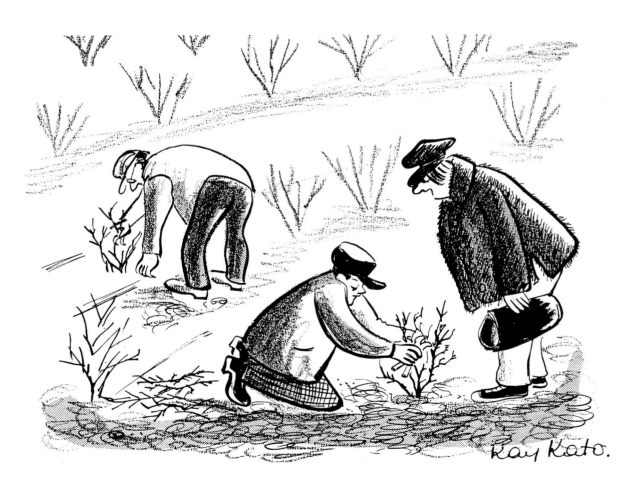

"Are you one of those professional rose-cutters?"

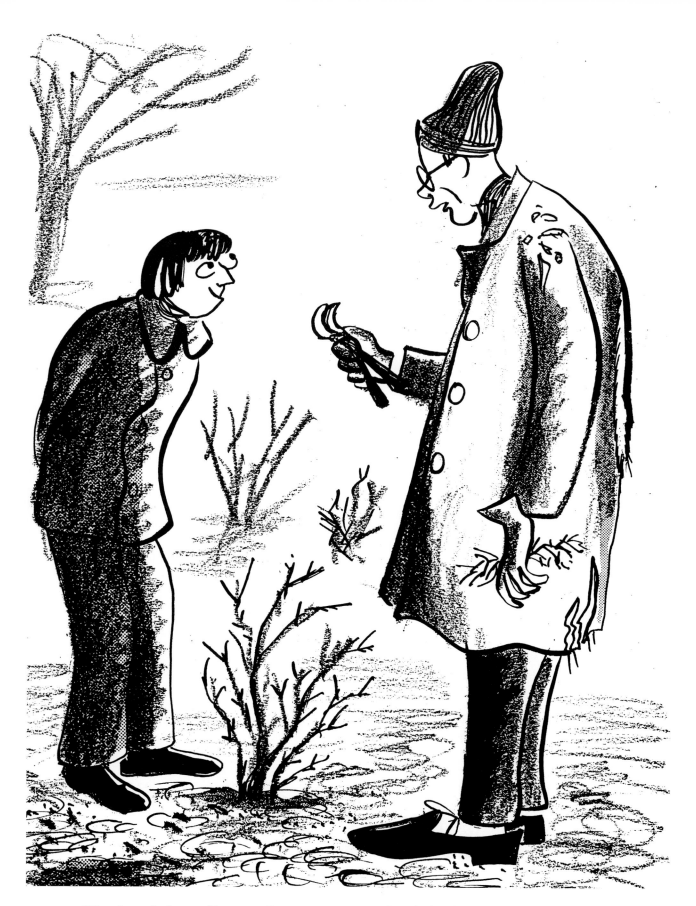

"I've heard that talking to flowers is supposed to help them, but talking to shears?"

20. Petanque

"Roll 'Em!"
(Brookdale Park)
August 22, 1976

Montclair sports fans have resurrected a game commonly played in the fifth century called "Petanque," the French version of the Italian game known as bocce.

The game is played with polished steel balls, instead of the wooden ones used in bocce.

Each game is played until a total of thirteen points are made, and I was told that most of the time, women win.

The game is especially convenient because it can be played on just about any flat surface.

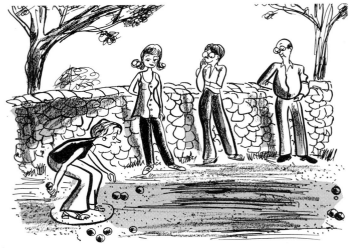

"I think I'd rather bowl."

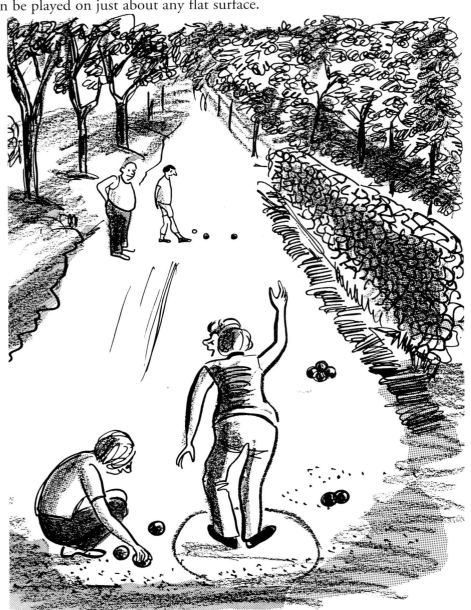

"Notice the clean follow through."

21. Kids Fishing

"Nature-Ally"
(Veronia Lake)
July 24, 1977

Environmentalists are stationed at Irvington, Verona, Branch Brook, Weequahic, and Orange Parks to help participants explore the flora and fauna.

The Commission has stocked the park lakes with numerous types of fish, including trout, carp, bass, blue gills, and sunfish.

At one park, youngsters patiently watched their lines in the water, waiting for a bite. They snagged shirts, pants, and socks, and only one fish. But they all seemed to enjoy their outing.

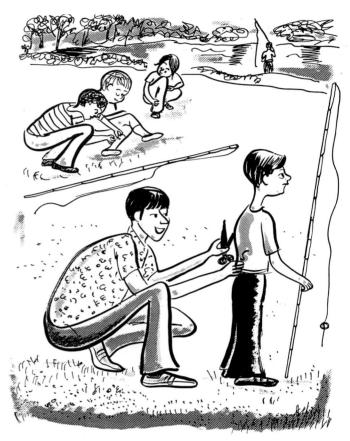

"Try to hook the fish, not your clothes."

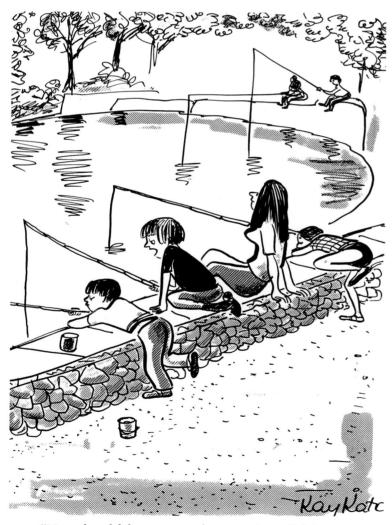

"You should have seen the one that didn't get away—he never came."

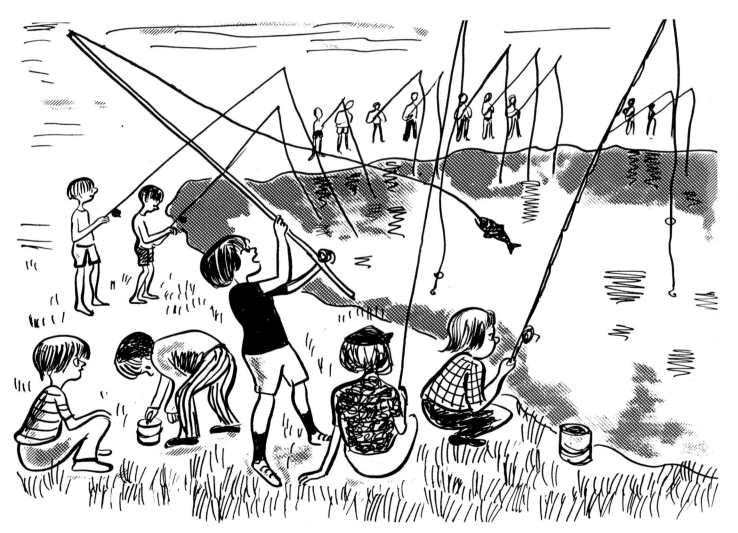

"I think it would be easier if we just went to the fish market."

22. Dinosaur Footprints

"Track Record"
(Riker Hill Park, Roseland)
November 13, 1977

Students at Montclair State College have gone on expeditions in search of footprints.

The students, enrolled in the school's paleontology division, travel to Roseland, to observe dinosaur prints dating back 190 million years.

Geologists say the dinosaurs which roamed Roseland centuries ago were the smaller ancestors of the huge dinosaurs that ruled the earth fifty to sixty million years ago.

Many of these extinct creatures left their footprints on red sandstone, and students found tracks belonging to dinosaurs that were about the size of large turkeys.

"This looks like a cousin of mine."

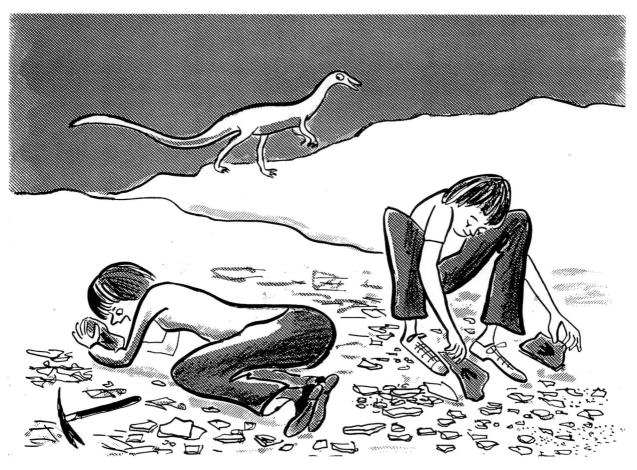

"Quite frankly, I don't believe they ever existed."

73

23. Concert in the Park

"Notes on Fun"
(Brookdale Park)
July 23, 1978

Beethoven, Tchaikovsky, Puccini, Verdi, and Gounod came to New Jersey last week, and whether the CBers know it or not—they came by truck.

Music by these legends was featured at a concert in Bloomfield's Brookdale Park as part of "Summer Festival '78."

The symphony orchestra drew a large crowd of about five thousand people.

The stage is also a big attraction. It is actually a truck which is operated hydraulically. There is also a telescope operated by air pressure.

These concerts are great for the family too. Many brought their supper, and two youngsters got so carried away with the concert that they tried to conduct the orchestra themselves.

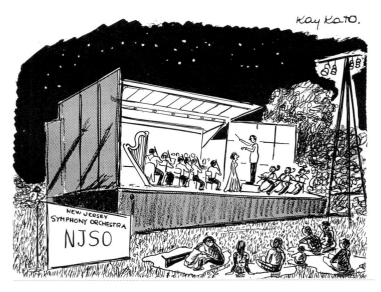

"I should have gone to Woodstock too."

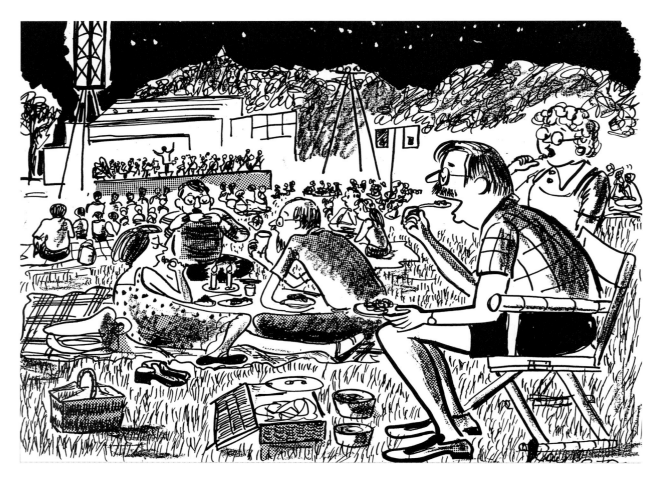

"Did we come here to eat or to listen to music?"

24. Girl Scout Camp

"Campy 'Clash' "
(South Mountain Reservation)
July 30, 1978

It was "Clash Day" and the "Swamp Witch" was there showing colorful slides about the Passaic River. She had startled the girls with a lifelike bat made of rubber and her green face and nails.

There was also a game that was played with a huge parachute at the day camp at the South Mountain Reservation in Maplewood.

The campers learn many skills there like making presents for the family or for themselves in arts and crafts.

But the four main objectives are on scouting: Deepening self-awareness, relating to others, developing values, and contributing to society.

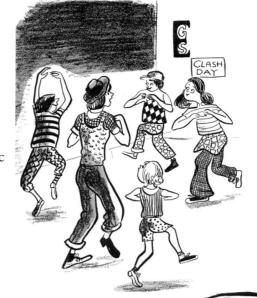

"I don't see what the big deal is about Clash Day— I just got dressed in my usual clothes."

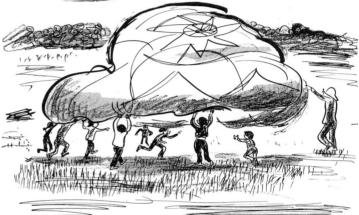

"Somebody said they spotted a UFO."

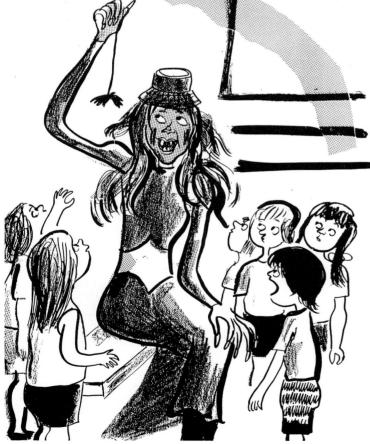

"After I went to the hair-dresser this morning . . ."

75

25. Lawn Bowling

"Bowling"
(Watsessing Park, Bloomfield)
September 10, 1978

Sir Francis Drake was playing it with his sea captains on Plymouth Hoe July 9, 1588, when he was notified that the Spanish Armada was sailing up the English Channel. Drake calmly said they would finish the game before tangling with the armada.

Lawn bowls came to America originally with the settlers from the British Isles and there are towns and cities in the nation still bearing the name "Bowling Green."

After a one-hundred-year lull, a New Jersey man named Christian Shepplin brought it back after he had tried the game during a visit to England and built a green on his own property.

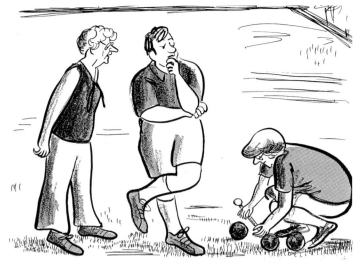

"I think the prize is under the second ball."

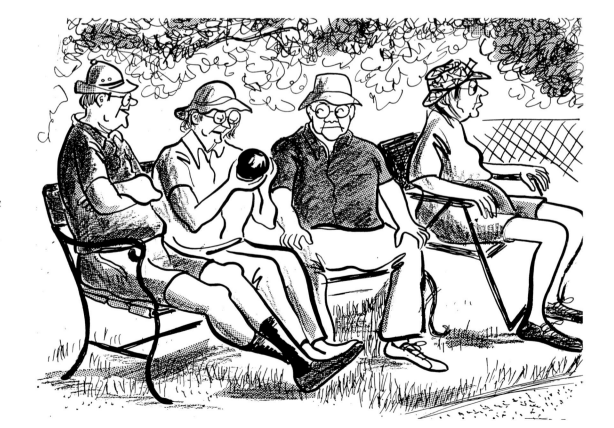

"Are you sure you can tell fortunes with this thing?"

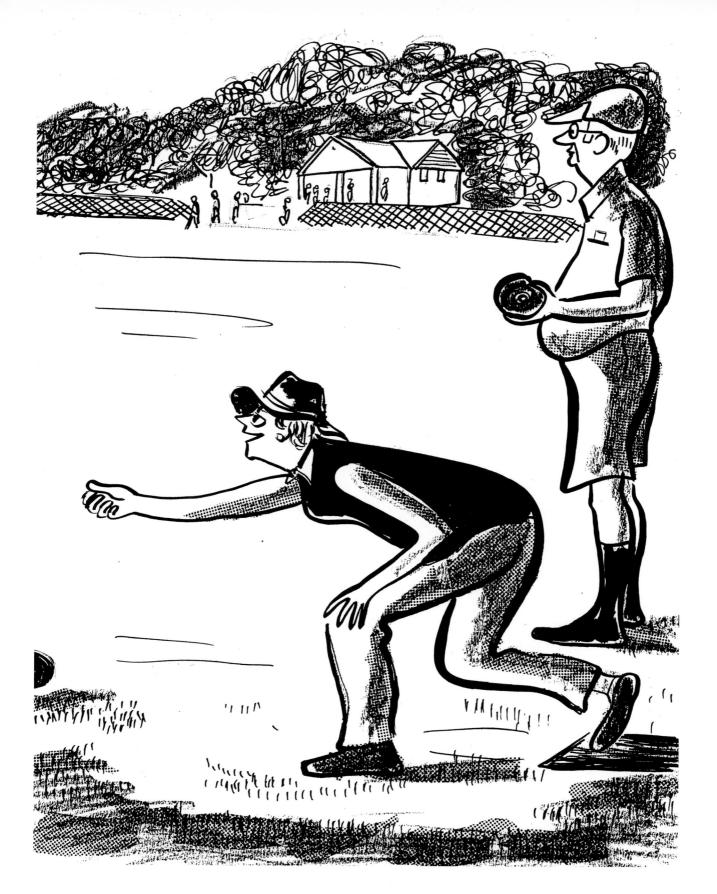

"Come on—you need to work off that stomach!"

26. Circus

"In the Act"
(Nutley)
September 17, 1978

Juggling, monkeys, lions, and elephants were among the attractions that came to town via the Hoxie Brothers Circus held at Glotzbach Park in Nutley.

Proceeds went to the restoration and preservation of Kingland Manor in Nutley.

A tall clown with a red nose took pictures of all the fun and during intermission kids were able to ride on the elephants to the music provided by an electric organ.

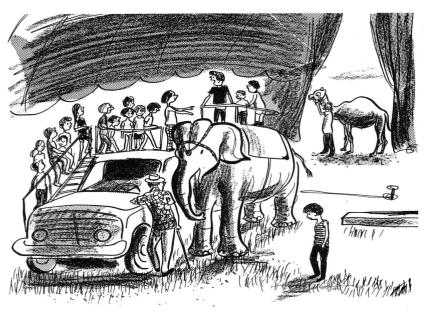

"You CAN smell the peanuts on an elephant's breath!"

"That's what I call hanging around."

"Don't your eyes get crossed after a while?"

27. Senior Broadway Show

"Revue Revels"
(Branch Brook Park)
September 24, 1978

One of the men was dressed as a Hawaiian girl complete with wig and a grass skirt, and a woman was dressed as a sailor.

This wasn't a masquerade party, but a scene from *South Pacific*, one of the productions presented by senior citizen clubs from five Essex County parks.

Sponsored by the Arts Council of North-West Essex and the Essex County Park Commission, seniors from Vailsburg, Branch Brook, Belleville, Verona, and Independence Parks gave members of other senior citizens clubs a "Broadway Revue."

Music was provided by tape and the seniors pantomimed the words to the famous Broadway numbers which included hits from *The Pajama Game* and *Oklahoma!*

"If my pants fall down during the performance, I'll be looking for YOU!"

"I always felt men and women should have equal opportunities."

"Why are we singing 'Hernando's Hideaway' when everyone can see he's right here?"

28. Clowns on The Green

"Clowning Around"

(Bloomfield)

October 1, 1978

A carnival with clowns, games, prizes, and lots of fun was held for the benefit of the Muscular Dystrophy Association by the Junior Women's Clubs of Belleville and Bloomfield.

The mayors of each town also made an appearance at the carnival where members of the clubs invented their own games, decided on the rules, and made the posters.

One of the games was the sandbox game where the prizes were buried under the sand in a sandbox and at the Toy Booth, one of the club members was dressed as Raggedy Ann with a red wool yarn wig and pantaloons.

One of the highlights of the contest given at The Green in Bloomfield, was a bubblegum blowing contest. The size of the bubble was measured with a "gumpter," one of the carnival's inventions, and several times during the day a puppet show was scheduled.

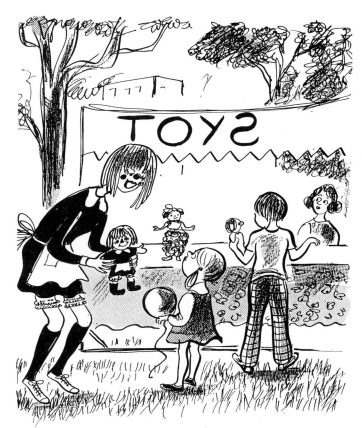

"I'm telling you kid, this isn't my daughter."

"If you don't like the puppets then I'll be forced to sing for you . . ."

29. Soccer

"Soccer It To 'Em"
(Meadowland Park, South Orange)
November 26, 1978

A soccer clinic, sponsored by the teachers in Maplewood and South Orange, was offered every Saturday at Meadowland Park in South Orange to boys and girls ages six through thirteen.

Under the direction of Gene Chyzowich of Columbia High School, the youngsters can learn the fundamental skills of soccer and the actual game.

At the clinic the players learn to hit the ball with a certain part of their head which is called "heading the ball" and is one of the fundamentals of the game taught by Tommy Parks, a soccer instructor from England.

"Is this how Joe Namath got his start?"

"You must have SOME headache!"

30. Dinosaur Park

"A Saur-y Time"
(Riker Hill Park)
December 17, 1978

"Walk with the dinosaurs . . . talk with the geologists," said the announcement inviting guests to the opening of the Geological Museum at Riker Hill Park in Livingston.

Geologists at the opening ceremony said the animals with footprints between one and twelve inches long, roamed the earth millions of years ago.

Smaller ancestors of the creatures date back to about two hundred million years—they were about the size of large turkeys.

Dinosaurs that lived in New Jersey were "Anchisauritus" (a small dinosaur), the "Grallator," and the "Eubrontes-Giganteus." The New Jersey creatures were the first to appear on earth.

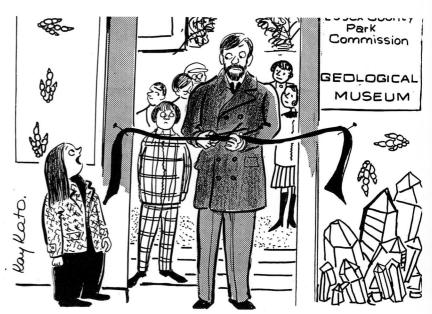

"Welcome to the dinosaur tail-cutting ceremony."

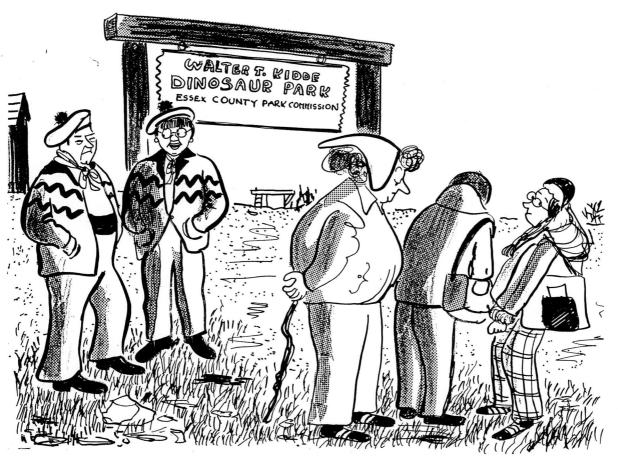

"I wonder how the dinosaurs liked Jersey."

"Ahoy Mates"
(Verona Lake)
July 8, 1979

Water sports are an important part of the summer months—and children and adults enjoy boating on Verona Lake.

Verona Lake, located in Verona Park, has twenty-six rowboats and fifteen pedalboats for rent on a bright sunny day.

The fifty-four-acre park is the only one in Essex County that offers boating to the public.

Michael Kazak of Newark is manager of the boathouse that opens at 10 a.m. weekdays and 9 a.m. on weekends.

The natural lake appears even more delightful when the bright yellow fiberglass boats are skimming across its surface.

"I've got the funniest feeling I'm going to slip and ruin the whole mood!"

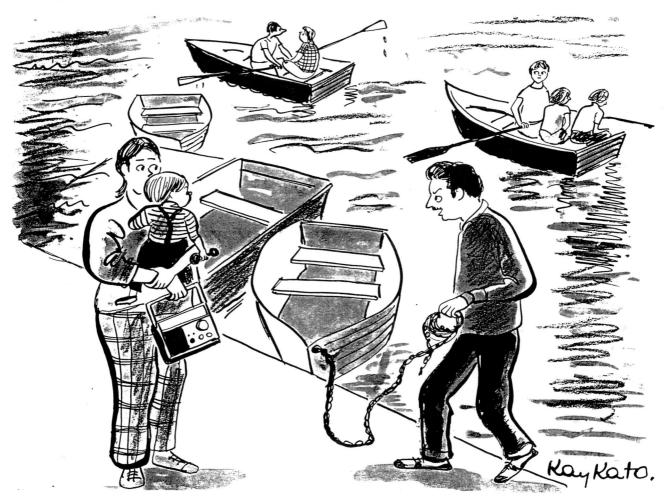

"What do you mean he wants to bring the TV—isn't the radio enough?"

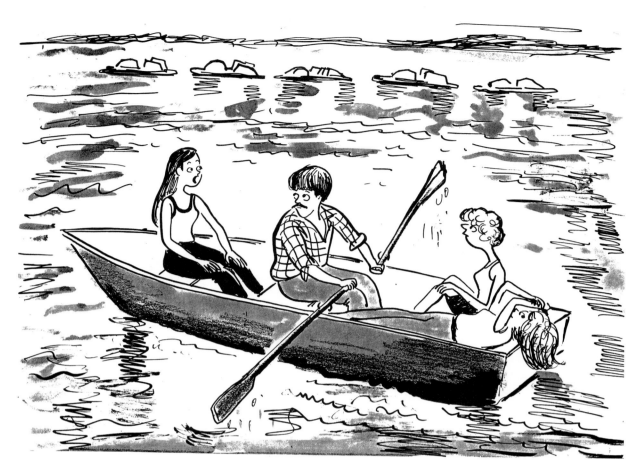

"Let me know when you get tired—we can idle for awhile."

"Gee, Hazel, from here it looks like you've lost weight."

32. Cherry Blossoms

"In the Pink"
(Branch Brook Park)
May 4, 1980

Washington, D.C. may be the capital of the United States, but Newark's Branch Brook Park is the capital of cherry blossoms.

In 1927, Caroline Bamberger Fuld toured Washington during the Cherry Blossom Festival and was impressed with the beautiful pink buds. She offered to donate more than two thousand cherry trees to the Essex County Park System, and now Branch Brook Park has one of the largest displays of cherry trees in the country, according to Liz Del Tufo, of the Essex County Department of Parks, Recreation and Cultural Affairs.

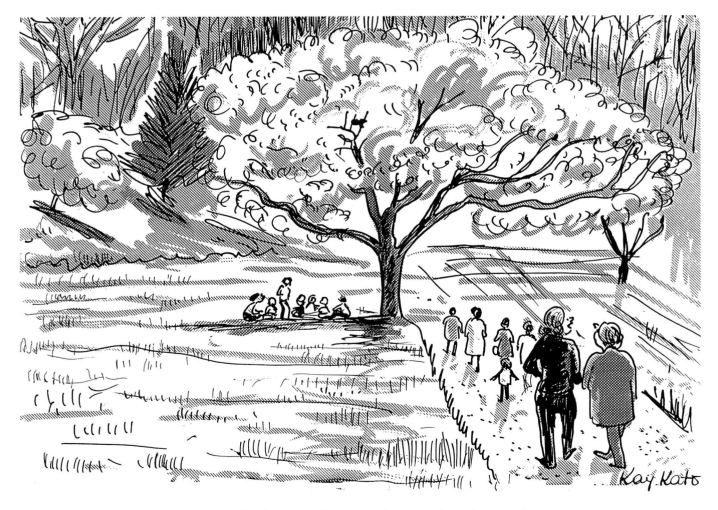

"The beauty almost makes you feel obsolete."

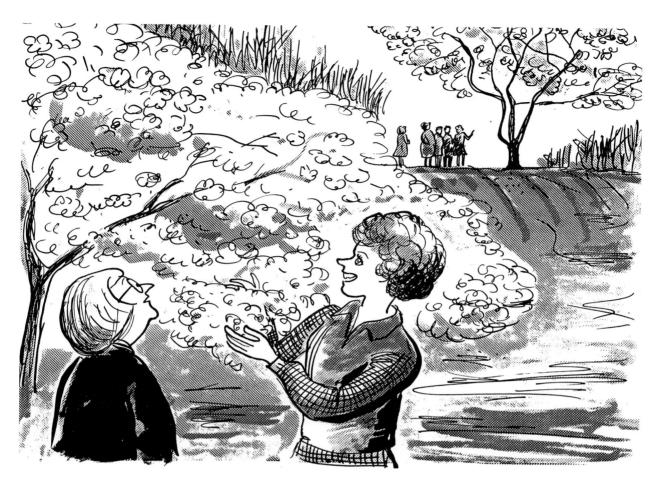

"They're so soft and fluffy, it reminds you of cotton."

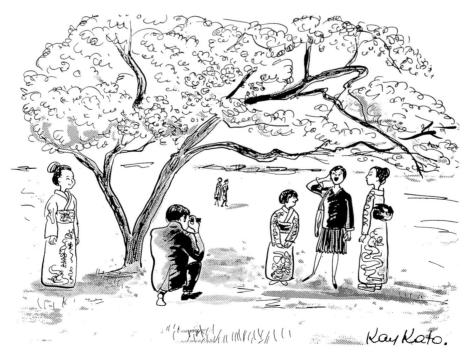

Kay Kato.

"I think I look great, but I must admit the kimonos do add more color."

"The serenity of nature."

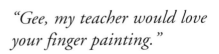
"Gee, my teacher would love your finger painting."

33. Plant Sale

"A Rosy Delight"
(Maplewood)
May 18, 1980

The Maplewood Garden Club held a four-day sale at the Maplewood Pool Parking Lot which attracted all kinds of plant lovers from those who find companionship in talking to plants to those who use them strictly for decorative purposes.

The club provided wheelbarrows and boxes to make shopping easier for the customers and there was also a special "Junior Garden Club" section which featured exhibits by children seven to twelve years old.

The proceeds from the sale will contribute to a Rutgers University scholarship and one to Columbia High School.

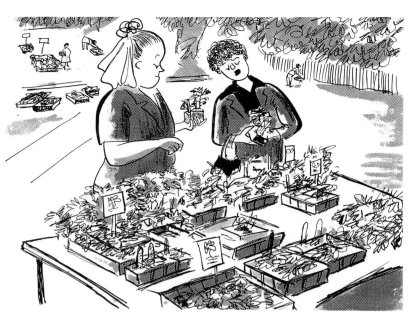

"There has to be some corner in my house where I can put just one more little plant."

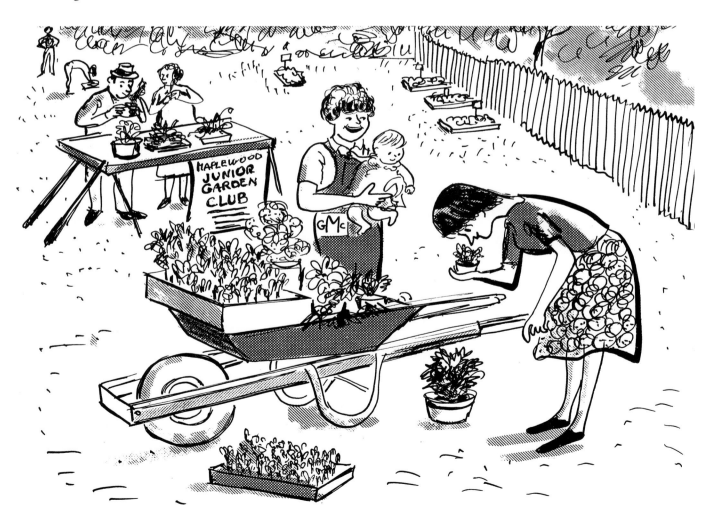

"Here's a junior plant for little Junior."

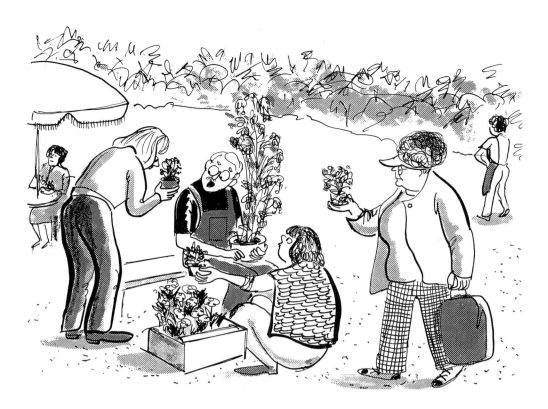

"I think we should get the one that's already shown it'll grow."

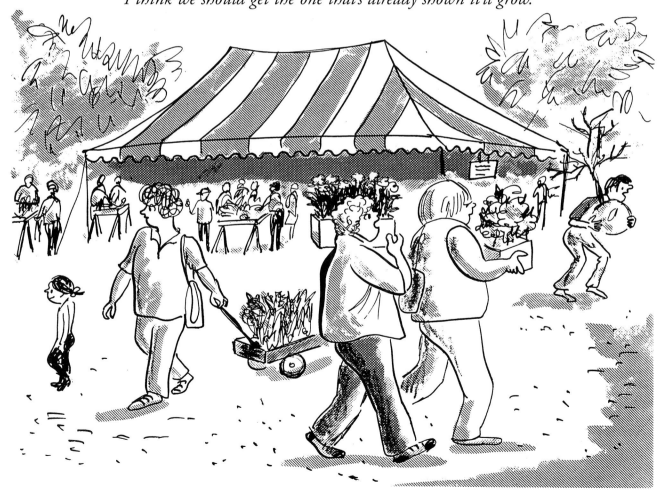

"Stop complaining—there're plenty more boxes to go."

34. School Carnival

"A Hit!"
(Bloomfield)
June 29, 1980

It was a day when the kids at the Watsessing School got to hit their classmates in the name of fun.

The event was the school's carnival which featured all of the popular carnival fare but included a "Hit the Face" game where children could stick their face through an opening in a cardboard structure and get hit with a wet sponge.

Also a favorite was an immense castle made out of rubber that the children jumped and bounced around in.

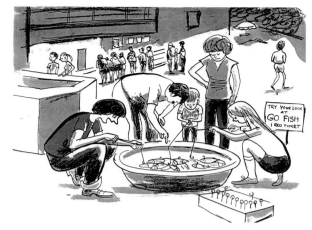

"I hope my parents aren't counting on me to catch one for dinner."

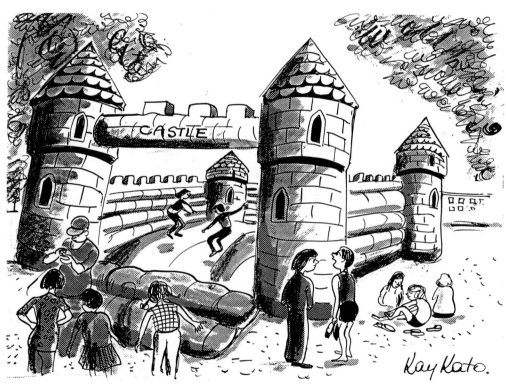

"Boy, and I thought my sand box was big."

"Now, remember, you can't put him in water with bubble bath."

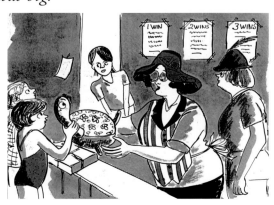

35. Golf (Essex County Executive Peter Shapiro)

"Linking Up"
(Weequahic Park, Newark)
June 28, 1981

The Essex County Department of Parks, Recreation and Cultural Affairs raised more than $1,500 in the first annual Michelob Lee Elder Golf Classic last week.

More than ninety golfers, representatives from private industry, participated in the event at the Weequahic Park in Newark to raise money for the Essex County Special Olympics.

The amateurs were joined by Lee Elder, a professional golfer from Washington, D.C.

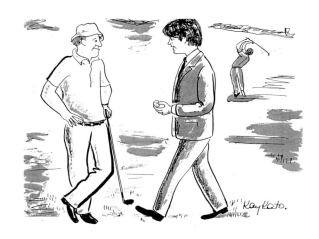

"Mind if I just watch?" asks Essex County Executive Peter Shapiro of Richard G. Schoon, president of the Greater Newark Chamber of Commerce.

Lee Elder thinks about a "birdie," but not the one this young spectator wants him to look at.

"I sure hope someone notices my form."

36. Tricentennial

"Artsy Affair"
(Verona Park)
July 18, 1982

Essex County celebrated its Tricentennial with an Art Alfresco gala event in Verona Park, Verona.

The Arts Council of Northwest Essex provided a demonstration of ivory carving, and some small animals from the Turtle Back Zoo were on display.

"Take your mask off first!"

"Three hundred years! I don't feel that old."

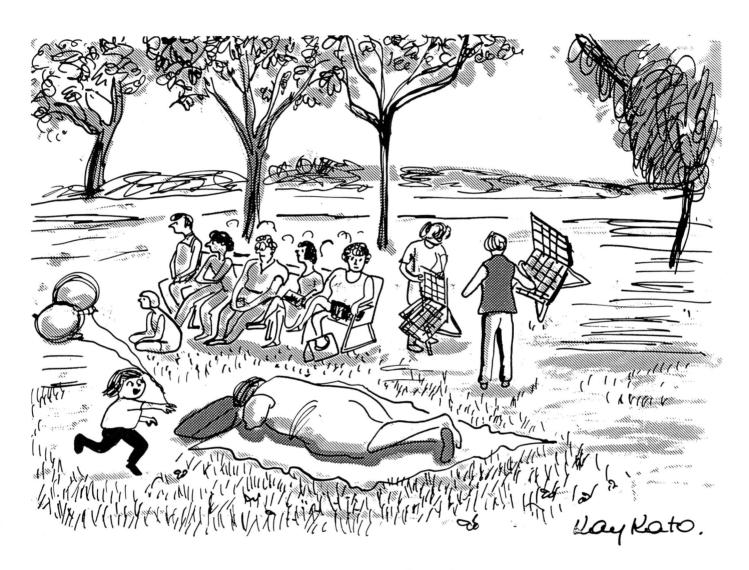

"Out of the way, lady, this is the runway!"

37. Tennis Complex (Althea Gibson)

"Court Manners"
(Branch Brook Park)
October 31, 1982

The new Branch Brook Park Tennis Complex was dedicated at a ceremony attended by political figures and tennis champion Althea Gibson.

The dedication ceremony was opened by Sylvia Guarino, vice chairwoman of the Friends of the Park for Branch Brook Park.

The $700,000 tennis complex includes twenty tennis courts, a clubhouse, and a playground area.

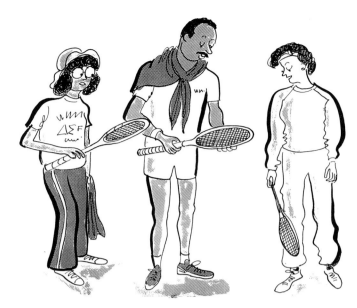

"This is real animal gut."

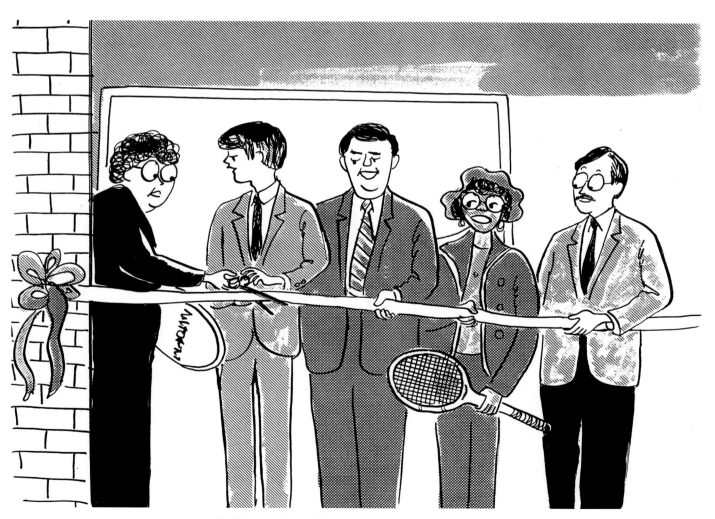

"This is the ribbon, isn't it, not the net?"

38. Softball Game (Jim Jensen)

"All-Stars"
(Maplewood)
August 7, 1983

There was plenty of action when the WCBS All-Stars visited Maplewood to play the Maplewood Recreation Department's Thursday Night Softball League All-Stars in a benefit game sponsored by South Orange Elks Lodge 1154.

Proceeds from the game went to assist handicapped children who attend Elks Camp Moore.

Jim Jensen, anchorman of WCBS News and team captain, was seeking to duplicate his pitching gem of last year when he threw a one-hitter. He succeeded.

The score was 7–0 in favor of the visiting team.

"Take this!"

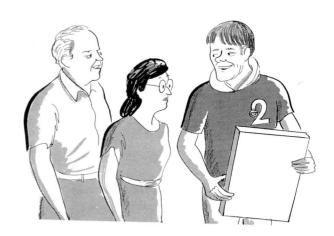

"It's a collage."

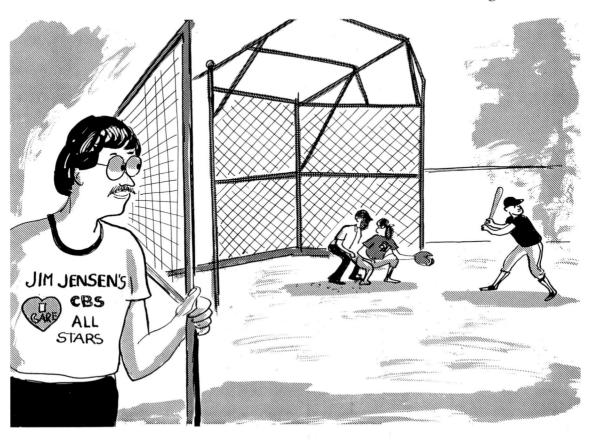

"I'm safe here."

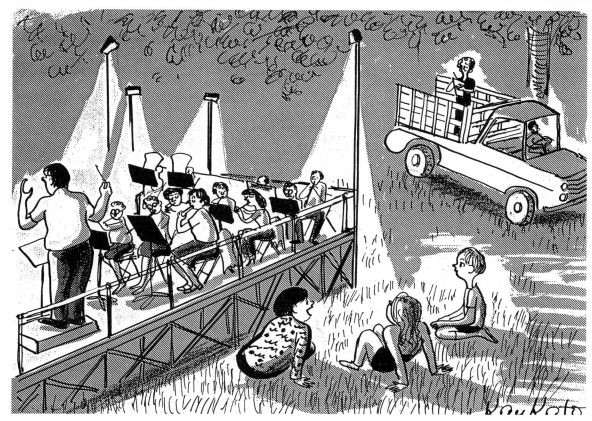

"Think I could join the band soon?"

39. Civic Band Concert

"Al Fresco"
(The Green, Bloomfield)
August 19, 1984

Amateur musicians from the Bloomfield Civic Band are celebrating their golden anniversary this year. They have been joining together for the last fifty years to give outdoor summer concerts "On the Green" in Bloomfield.

Ranging in age from thirteen to seventy, the band has a total membership of seventy musicians.

This summer the band has given five concerts with Dominick Ferrara of Bloomfield conducting. Since Ferrara's two daughters are in the band, one playing oboe, the other flute and bassoon, they receive special attention.

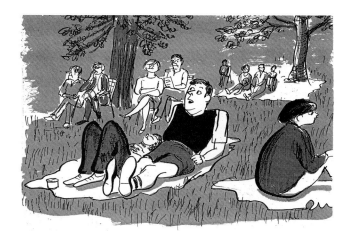

"This beats watching sports."

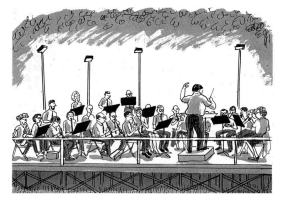

"With gusto!"

40. Folk Festival

"Plain Folks"
(Eagle Rock Reservation, West Orange)
July 7, 1985

The Eagle Rock Folk Festival is the largest continuing festival of folk music and crafts in New Jersey sponsored by Folk Music Society of Northern New Jersey.

Local talent and nationally acclaimed folk musicians performed before relaxed crowds on the spacious lawns of the reservation.

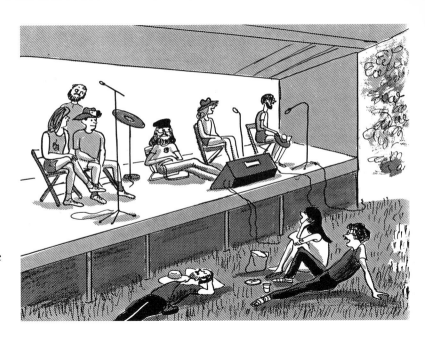

"One down, two to go."

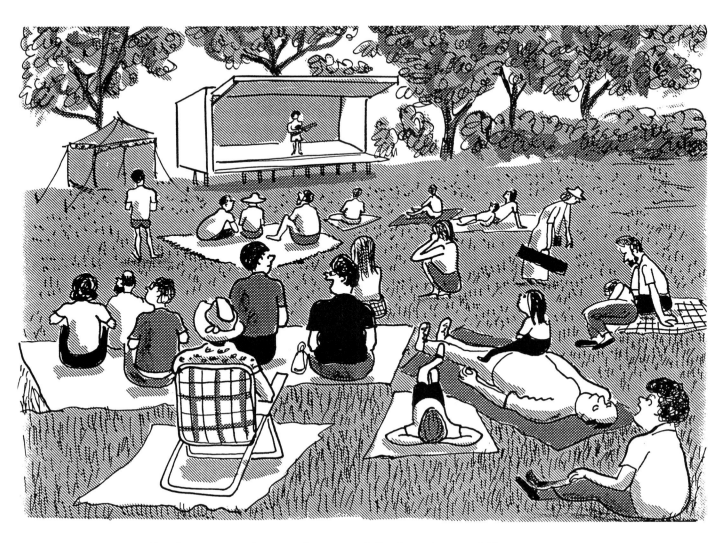

Park visitors relax in the sun while listening to folk concert.

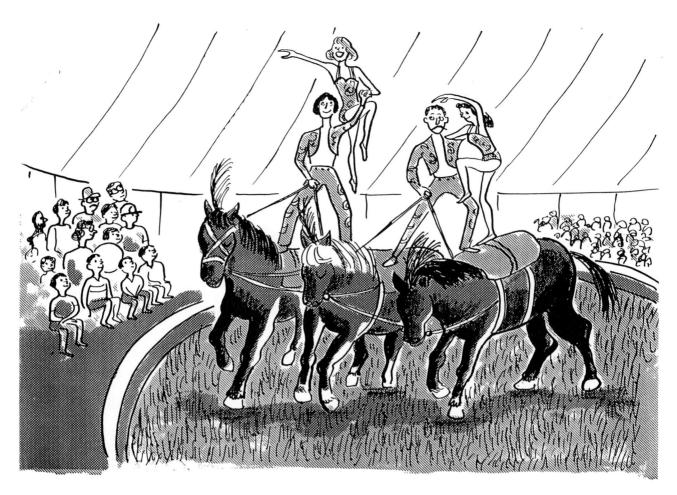

"I'm not as young as I used to be."

41. Circus

"Three-Ringer"
(Maplewood Park)
July 21, 1985

The Great American Circus brought its animals, clowns, acrobats, and special guest Tiny Tim to several New Jersey locations over the past month.

The circus was founded in 1941 as Hoxie Brother Circus.

The Great American Circus entertained audiences in thirty-nine towns in New Jersey.

The performers must help with the traveling chores and preparations for each show. Even the elephants help; they push up the poles and pull out the stakes for each performance.

"What happens if she falls?"

"He's trying to walk on his tip-toes."

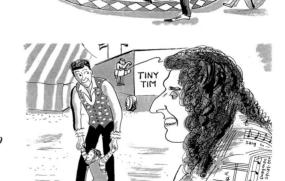

42. African Drummers

"Branch Out"
(Branch Brook Park)
September 1, 1985

The stars came out in Newark's Branch Brook Park for Summerfest '85, a series of free concerts and performances.

Two of the groups featured in the outdoor productions included Gallman's Newark Dance Theatre and the African Unity Drummers and Dancers, a troupe dedicated to the presesrvation of traditional African music, dance, and costume.

Concert-goers spread their blankets and picnics, settled back in their lawn chairs, and enjoyed the show.

"This is a good spot for our 'Green Room.' "

The sounds of different drummers.

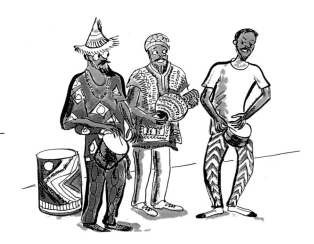

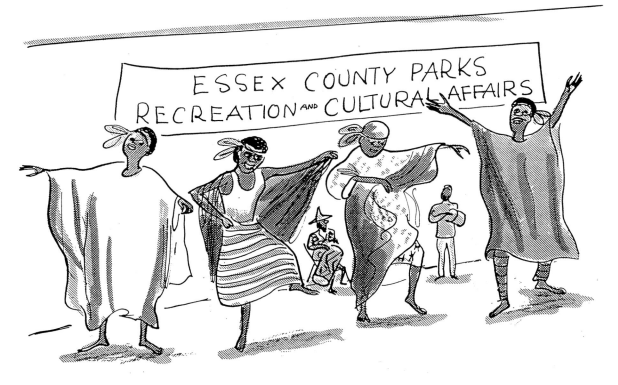

The African Unity Dancers demonstrate some fancy footwork.

43. Bike-a-Thon

"The Wheel Stuff"

(Branch Brook Park)
June 15, 1986

Pedal for Progress, a bike-a-thon for the American Diabetes Association, was held at four locations in the state, creating a "simultaneous ride" to raise money for diabetes research.

The participants gathered sponsors, who pledged money for each mile the biker covered in the four-hour time limit.

Dave Lewis, defenseman for the New Jersey Devils hockey team, served as honorary chairman. Each participant with three or more sponsors received a free T-shirt with the slogan "Pedal for Progress" inscribed on the front.

"*Wanna race?*"

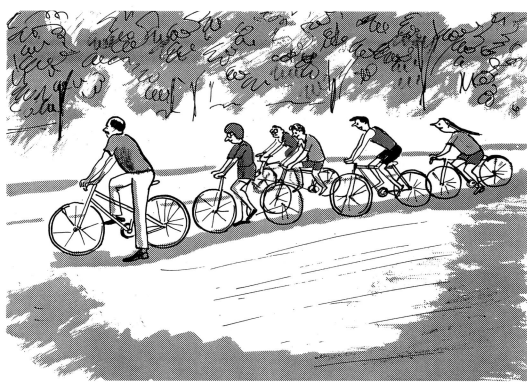

"*I've been following the guy with the blue shorts for miles.*"

"*You're not playing tick-tack-toe, are you?*"

44. Pie Eating

"Pie-Faced"
(Maplewood Park)
July 27, 1986

The Maplewood Annual Festival, sponsored by the Maplewood Civic Association and the Junior Women's Club of Maplewood, entertained dozens of school children at the picnic area of Memorial Park.

The ice cream eating contest was the most popular, with pie-eating pushing a close second.

High schoolers participated in an unusual milk drinking contest in which each contestant reclined on his back and drank from a baby bottle.

"But I don't like chocolate ice cream."

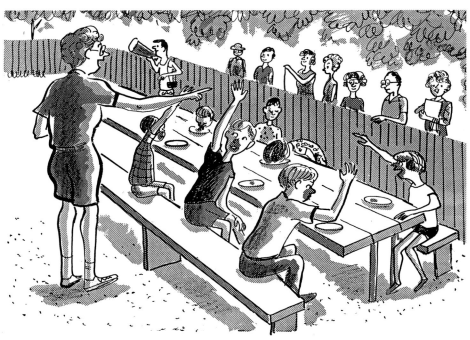

"The boy with the blue face is the winner."

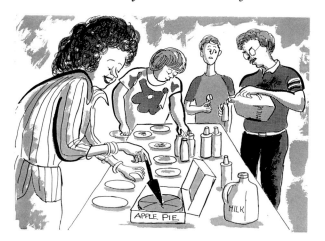

"Should I make the pieces bigger for the older kids?"

45. Indian Independence Day

"Indian Fete"
(Brookdale Park)
August 31, 1986

Indian food, cultural dances, and music were part of the celebration of the Thirty-ninth Indian Independence Day in Brookdale Park, Bloomfield. Proclaimed India Day, the festival was sponsored by the Coalition of Indian Organizations of New Jersey.

Foods and snacks were available during the celebration, as well as a variety of sweets made primarily of nuts.

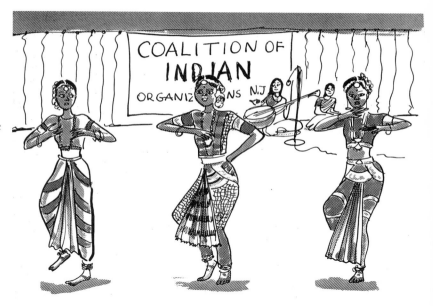

"Smile, and pretend we're the opening act."

"Stand still. You're not dancing yet!"

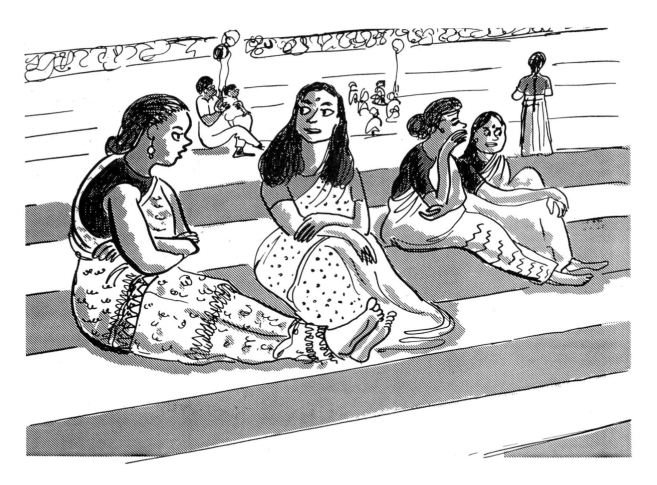

"I hope the little girls aren't better than we were."

46. Haitian Festival

"Island Lore"
(Branch Brook Park)
September 14, 1986

 Fire dancing and native works of art were in the offing for the Haitian Festival held at the Northern Extension of Branch Brook Park.
 Center stage were the Caribbean Folklore Dancers who, with their colorful costumes, were celebrating their Independence Day in 1804.

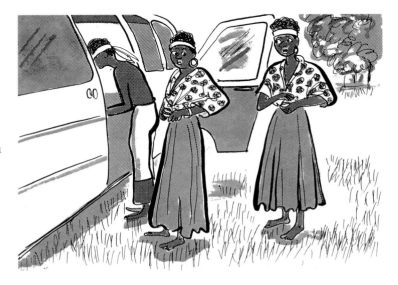

"Ready when you are."

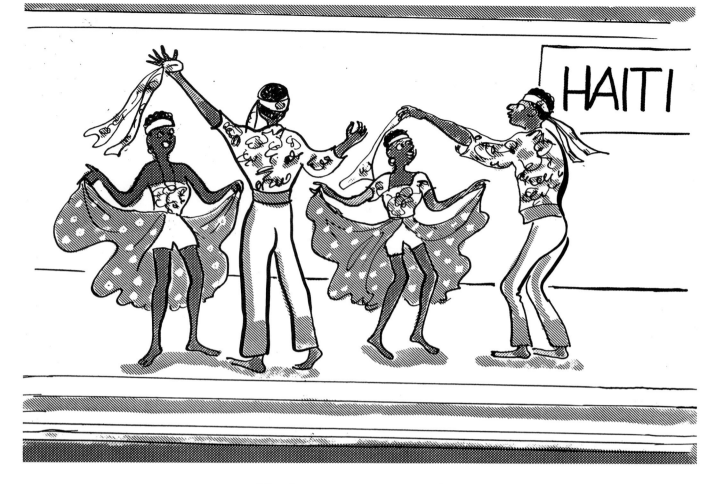

"I'm beginning to see spots!"

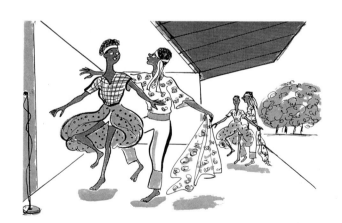

"Keep your eye on the end of the stage."

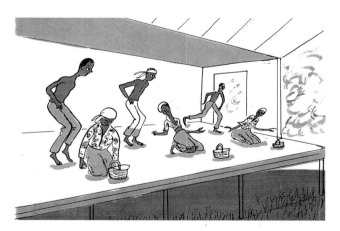

"When do we get to stand up?"

47. Court Judges Play Softball

"Ball, Bat & Bar"
(Bloomfield)
June 21, 1987

Essex County Superior Court judges and the court's law clerks went to bat for Legal Aid Services during a fund-raising exhibition game of softball at Pulaski Park in Bloomfield.

Among the playing judges, who all wore "Essex County Benchwarmers" T-shirts, were a woman judge and a judge who had just received a heart transplant.

Attorney Richard Trenk, who clerked five years ago for Judge Julius Feinberg, organized the Legal Aid 1987 Softball Tournament, which was sponsored by the Legal Services Foundation of Essex County. Legal Aid Services provides legal aid to those people who might not otherwise be able to afford it.

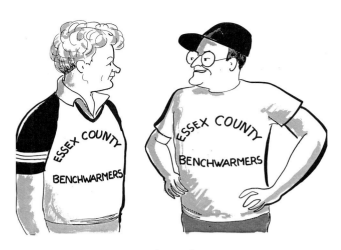

"Would it look good in the courtroom?"

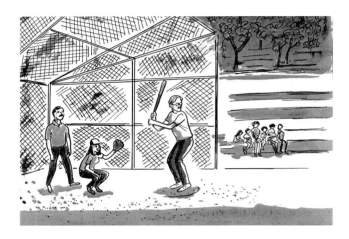

"Strikeout verdict!"

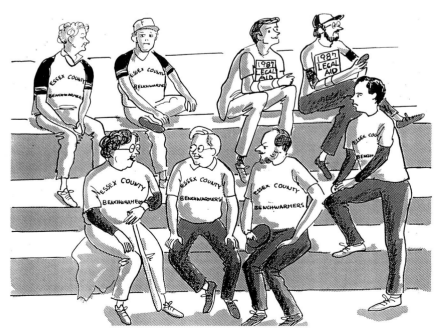

"My clerk doesn't have a hit yet!"

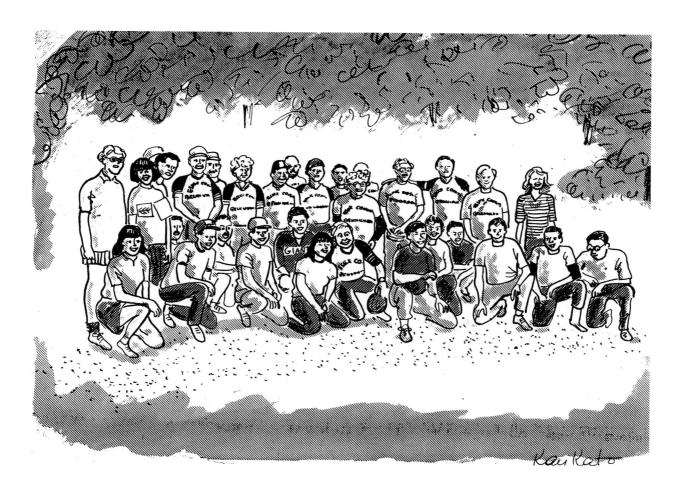

Essex County softball team for Legal Aid Services.

48. 4-H Fair

"All's Fair"

(Brookdale Park)

August 23, 1987

The Essex County 4-H Fair and Children's Festival was held at the Brookdale Park, Bellevue Avenue, Bloomfield. The event included a modeling and fashion show, a teen rock band, a dance demonstration, and a seeing-eye dog demonstration.

Roving clowns distributed balloons to the guests, while the Turtle Back Zoo, West Orange, displayed a de-scented skunk.

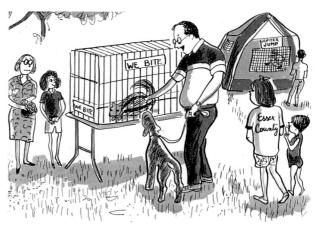

"Don't worry, he doesn't stink."

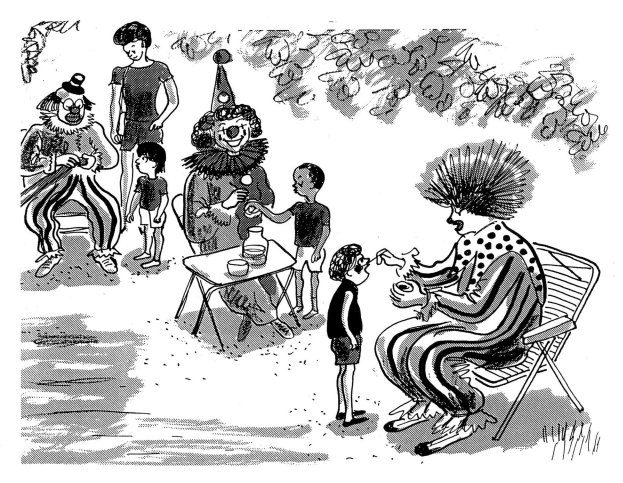

"Will you make my hair look like yours?"

"No dear, you don't wear that suit to bed."

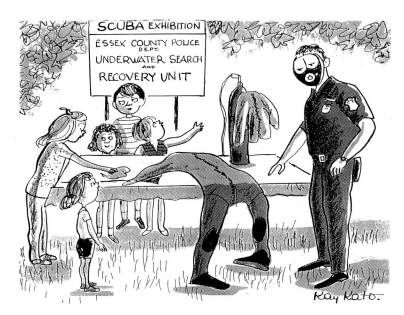

49. British Faire

"A Day at the Faire"
(Edgemont Park, Montclair)
May 27, 1990

A cricket clinic, pony rides, and Gaelic and Irish lessons were among the events at the Sixth Annual Country Faire at Edgemont Park, Montclair.

The event, which started off with the crowning of the May Queen, was sponsored by the Friends of Barnett and the Parks and Recreation Department of Montclair, all being part of the May in Montclair celebration.

"My, what a lovely day!"

"Like it?"

"Higher, higher!"

50. Met in the Park

"Very Verdi"
(Brookdale Park)
July 15, 1990

Technicians from the Metropolitan Opera Company had their work cut out for them when they started at 5 a.m. one morning to set up a light system and a sound stage for the Met's production of *Rigoletto*, performed at Brookdale Park in Bloomfield as the fourth annual "Met in the Park" presentation funded in part by Chemical Bank. Almost two hundred chorus members, orchestra players, and principal vocalists were involved in *Rigoletto*.

"What a lovely voice you have, Ms. Swenson!"

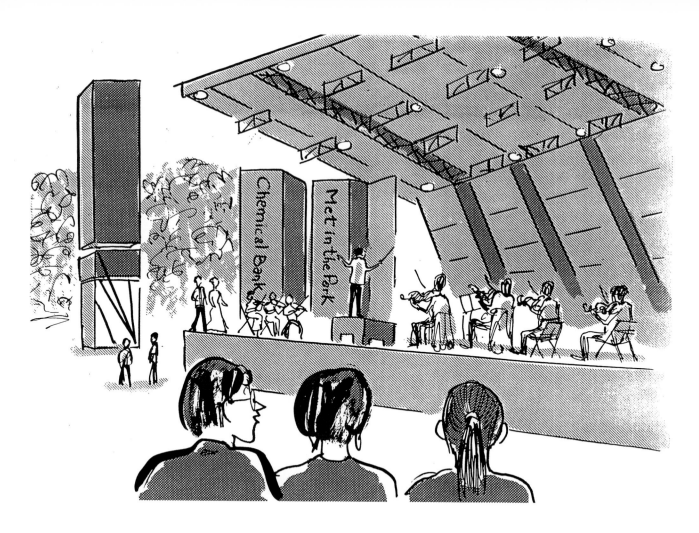

"If he's not careful, he's going to conduct himself right off that stage!"

"You see, she wants him to be first violinist by the time he's twenty!"

51. 4-H Fair Youth Festival

"A Fair Portrayal"
(Brookdale Park)
August 4, 1991

The fiftieth annual Essex County 4-H Fair and Youth Festival at the Brookdale County Park in Bloomfield, featured everything from cloggers and Kung Fu to an appearance by a Teenage Mutant Ninja Turtle.

While the turtle posed for photos with some of the seven- to nineteen-year-old youngsters, others demonstrated their skills in dog training, horseback riding, singing, and the martial arts.

"Mommy, Mommy, can I keep him?"

Jumping for joy.

"I wonder what she really looks like . . ."

Kay Kato.

52. Day Camp

"Warm Welcome"

(Belleville)

August 11, 1991

A Summer Day Camp program was held at the Branch Brook, Belleville, Grover Cleveland, Independence, Irvington, Ivy Hill, Watsessing, and Yanticaw Parks each year.

When the last camp sessions ended, the camps opened their doors to parents and grandparents for Family Day.

"Son, what are you hiding behind your back?"

"Careful you don't fall!"

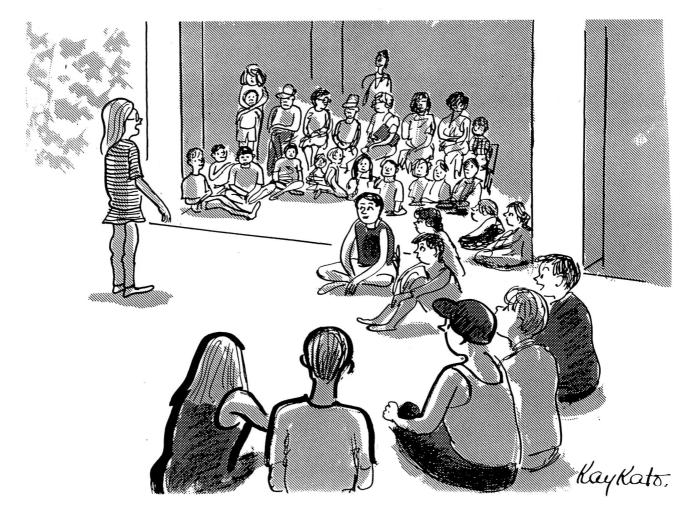

"Once upon a time . . ."

53. History and Heritage Fair

"Camping in History"
(South Mountain Reservation)
November 8, 1992

History came alive at South Mountain Reservation in West Orange when the New Jersey Muzzle Loading Association sponsored the second annual Heritage and History Fair.

Participants in the encampment dressed in period costumes ranging from Colonial times through the Spanish-American War era, set up tents, and dined on a pig they roasted themselves. The association brought in two cannons, one of them an original Civil War–era cannon and the other a replica.

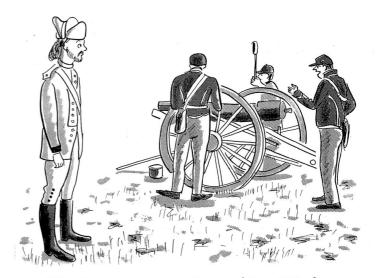

"Don't pay any attention to him. He's from another war."

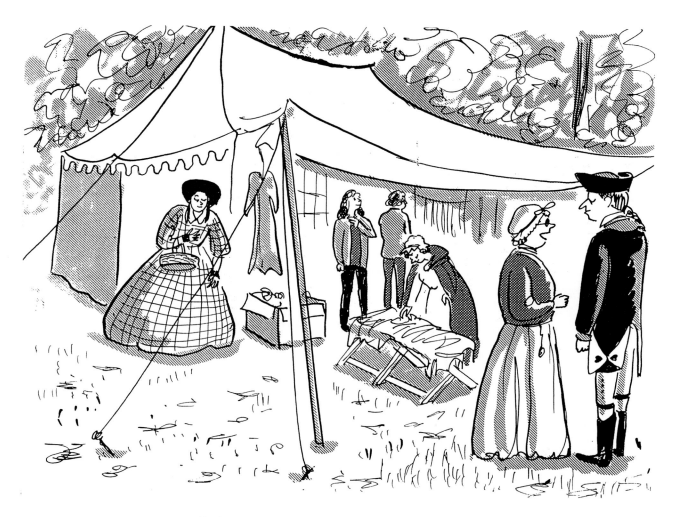

"All the comforts of home—eighteenth-century style."

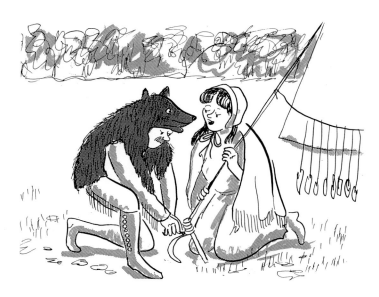

Dances with Bears.

54. Arts and Crafts

"From Soup to Nutley"
(Memorial Park, Nutley)
October 3, 1993

The twentieth annual Festival-in-the-Park was held at Nutley Memorial Park in Nutley. Begun in 1974 by the Garden Club, the arts and crafts show is now sponsored by the Nutley Historical Society and the Kingsland Trust, which is in the process of restoring the Kingsland Manor.

"Stop horsin' around!"

"The witching hour."

"I've spent my life pulling strings."

55. Encampment

"As You Were"
(Taylor Park, Millburn)
July 23, 1995

Morgan Rifle Corps Inc., is a New Jersey group dedicated to researching and re-enacting events and experiences of the American Revolution. Under the leadership of Commander Richard Clair of Convent Station, the Corps held an encampment at Taylor Park in Millburn.

Dressed in outfits based on those worn in 1775, the Corps played period games with local children, and demonstrated such colonial tasks as gunsmithing, flax spinning, basketry, and campfire cooking.

"Gimme that number, girlfriend! He is fine!"

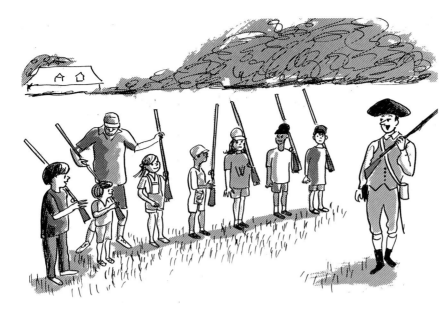

"Lisa! Which amendment do we cite when the AFT tries to take our guns?"

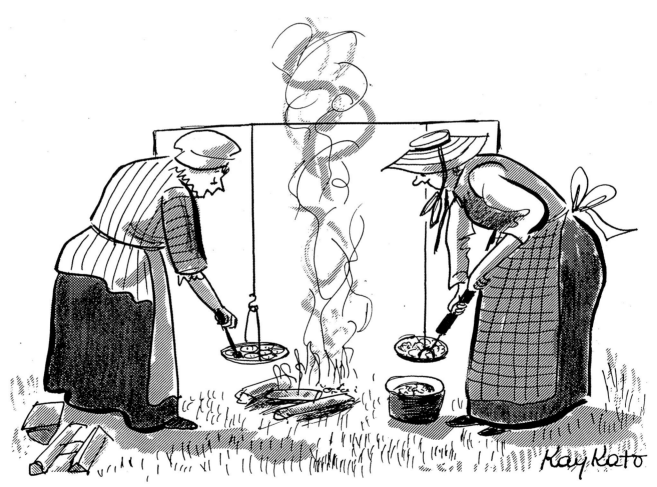

"Oh, yeah, if one falls into the fire, I just throw it back in the pot."

Chapter 3

1. June 16, 1974 Frog Walk
2. August 3, 1975 River Seine
3. March 21, 1976 Natural Tinting
4. August 29, 1976 Camp-Out
5. May 8, 1977 Sheep Shearing
6. February 4, 1979 Woodcarving
7. February 18, 1979 Telescopes
8. May 6, 1979 Nature Walk
9. February 10, 1980 Bird Banding
10. January 18, 1981 Natural Dyeing
11. May 3, 1981 Puppet Making
12. August 23, 1981 Blowing Bubbles
13. January 10, 1982 Papermaking
14. August 1, 1982 Canoe Clinic
15. September 19, 1982 Forager's Feast
16. January 16, 1983 Barn Dance
17. May 15, 1983 Photo Expedition
18. October 2, 1983 Dances of the 30s and 40s
19. December 18, 1983 Toys
20. November 25, 1984 Carp Fishing
21. April 28, 1985 Yoga for Kids
22. July 13, 1986 Canoe Trip
23. October 25, 1987 Farm
24. September 4, 1988 Sunflower Contest
25. January 1, 1989 Firewood
26. June 4, 1995 Beekeepers

Chapter 3 **Environmental Center**

1. Frog Walk

"Into the Hopper"
June 6, 1974

At the walk on "Frogs and Other Hoppy Things," over sixty children and parents participated.

David Hulmes, president of the New York Herpetological Society, showed slides of frogs.

Afterward the group, with boots and flashlights, set off on a trek through Hatfield Swamp, in West Essex Park, West Caldwell. They braved mud and mosquitos to get to the frog pond.

The pond contained bullfrogs, green frogs, and spring peepers.

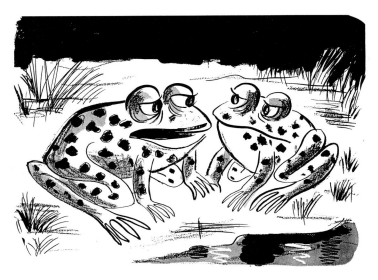

"I wouldn't let those humans handle me—they give you warts."

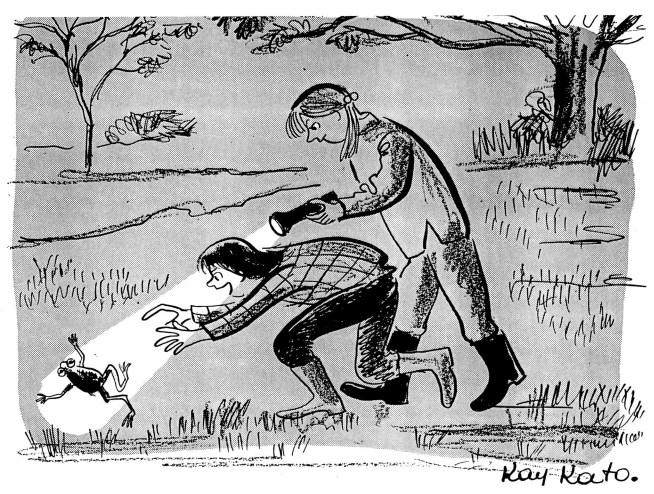

"Come on frog. This is your big chance for stardom."

"Somebody tell her it won't really turn into a prince!"

"You'll notice frogs have no ears. That's one reason why they're so fond of rock music."

2. River Seine

"Seine in, Please"
August 3, 1975

A "Passaic River Seine" was sponsored to examine the inhabitants of the river.

After viewing slides of the river, we went outdoors to try to place poles on a forty-foot seining net, which later was dropped into the river from a canoe by naturalists from the center.

Although few fishes were caught, the seine proved to be a unique learning experience.

"I bet he's examining you, too."

"I still say this thing belongs in an art museum."

"I think he lost one of his contact lenses."

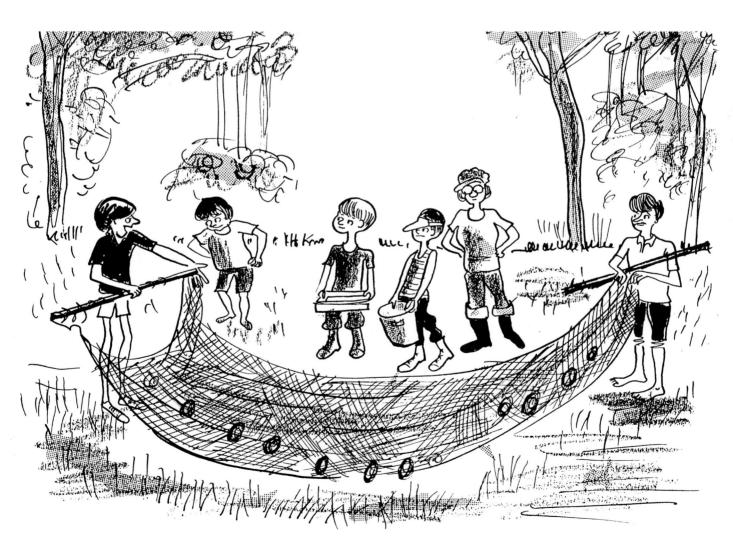

"If this doesn't work, I'm going back to using a fishing pole."

3. Natural Tinting

"Tinting Tonight"
March 21, 1976

Instead of trying to match a color scheme in stores, it is sometimes easier and less time consuming to dye your own materials.

Yarn used during the workshop was imported from Greece, while dyes used came from roots, barks, and resins of trees in Brazil and Central America.

But some dyes are made from insects, I was told. "Scale" insects, which make their home on cactus plants in Mexico, are used in creating red and purple dyes.

"This reminds me of the time I first learned how to cook."

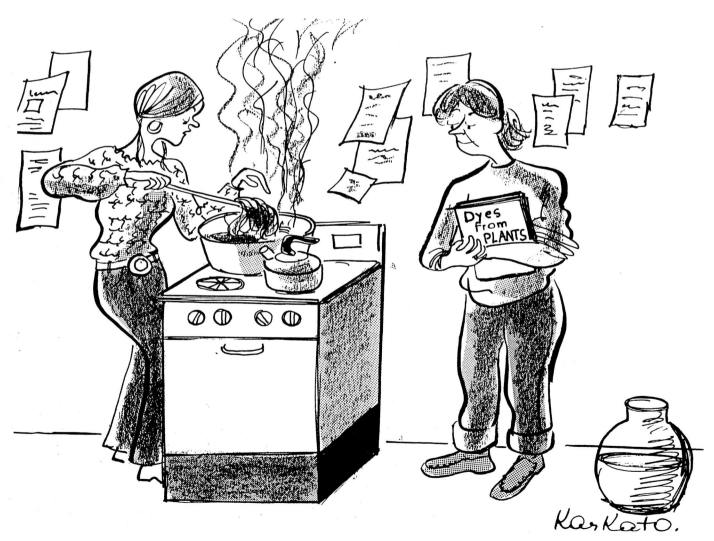

"There is something floating around in this water. It looks like a rose."

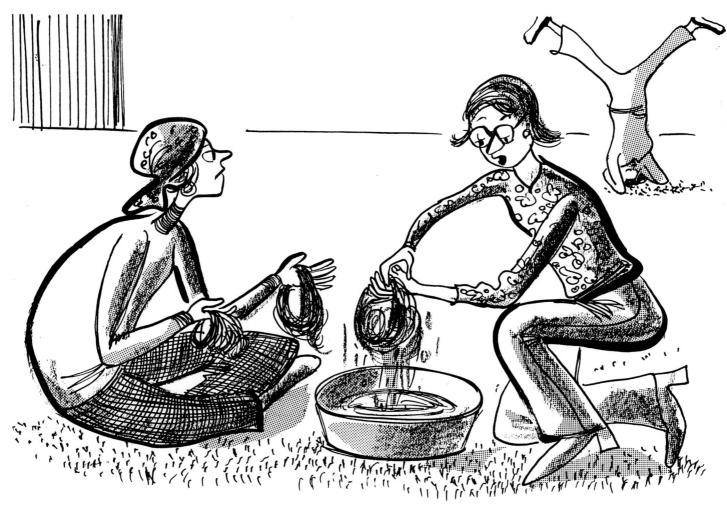

"I guess he's trying to tell us he doesn't like our work."

"Just think. In a few minutes, this will be a sweater."

125

4. Camp-Out

"Family Tent-Out"
August 29, 1976

West Essex Park was the setting for a family camp-out.

The affair afforded many families an opportunity to spend time together in the outdoors and to work on projects as a unit.

One project was setting up tents, of which there were almost as many kinds as there were campers.

Many campers brought guitars and banjos and sang near an open fire.

"I guess you really can cook food better at home."

". . . And this will be the pool room."

"I knew something was missing: the mosquitoes!"

5. Sheep Shearing

"Shear Delight"
May 8, 1977

Visitors to the Center for Environmental Studies in Roseland discovered uses for sheep other than lamb chops.

The Center was the scene of a sheep-shearing demonstration sponsored by the Essex County Park Commission as part of the organization's spring programming.

The demonstration was entitled "Sheep to Shawl," and participants were shown everything from the skinning of the sheep to how to make woolen materials.

The instructors, with the aid of willing sheep, demonstrated the six steps: Shearing, combing (carding), spinning, washing, dyeing, and weaving.

It was explained that in most cases, sheep are sheared once a year, with a yield of about fifteen to twenty-two pounds of wool, a drastic difference from Colonial times.

Then, the most that could be expected was about two pounds of wool, due to the slower methods used at the time.

"This should go well with your new earrings."

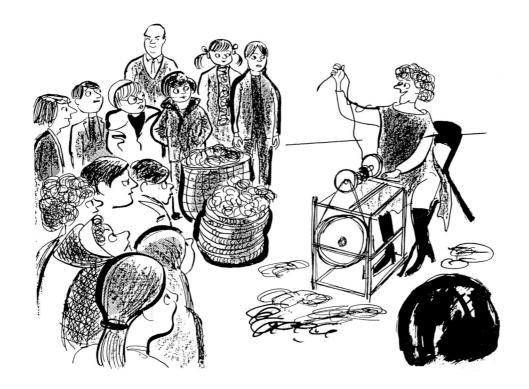

"And this is the product of generations of sheep."

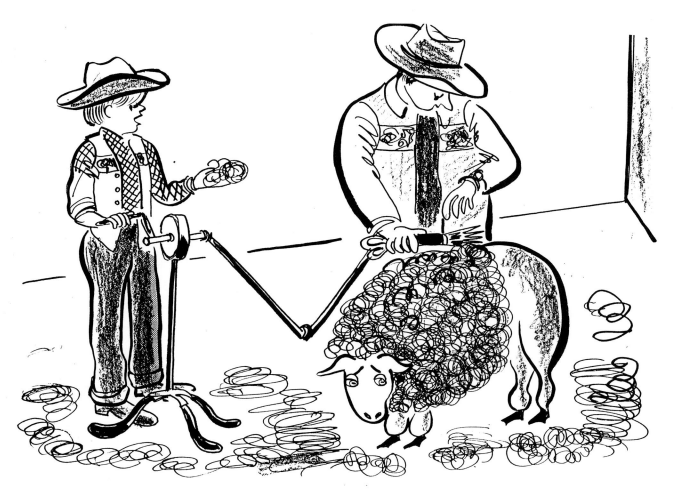

"I think he had dandruff."

6. Woodcarving

"Real Cutups"
February 4, 1979

"If you can peel a potato, you can do wood-carving," the instructor told one of his woodcarving class students.

As an art, woodcarving goes back to the Stone Age and today's primitive people still do woodcarving to create many daily needs.

The students also learn about glueing, finishing, and tool sharpening. The wood used in the class I visited was pine and bass wood.

"I feel like saying 'pass the potatoes.'"

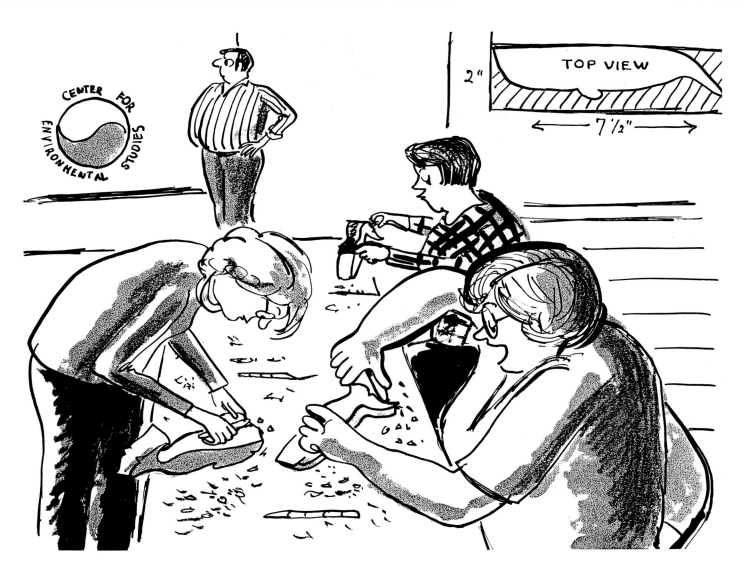

"I'm glad I don't have to go through this with cucumbers."

"I thought this was going to happen."

7. Telescopes

"Starry-Eyed"
February 18, 1979

You've probably looked through a telescope, but have you ever tried making one? A lecture-demonstration on the techniques of telescope-making was presented here.

It is often said that astronomy is the oldest of the sciences and there is a possibility that the story of the telescope goes back to ancient times—the astronomer-priests of the Nile had developed some sort of optical instrument, the secret of which was later lost.

The actual story of the telescope begins in or about the year 1608 when Hans Lippersheim, a spectacle-maker in Holland announced that he invented an instrument with which he could "see at a distance."

"Are you sure grinding this mirror won't give me seven years bad luck?"

"Maybe this could help me become a TV cameraman."

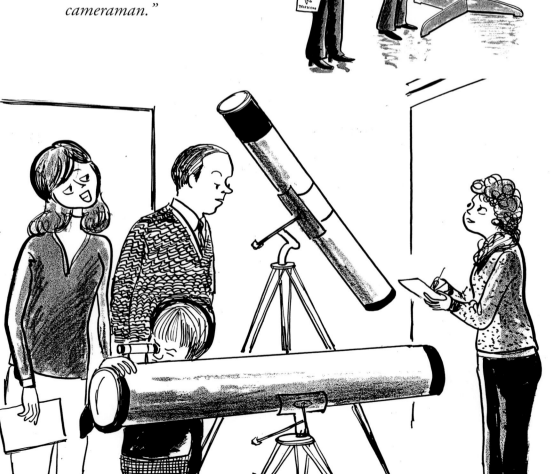

"How come I can't see any farther than the wall?"

8. Nature Walk

"Flower Children"
May 6, 1979

There's a new "flower" blooming on the Swinefield Interpretive Trail in Livingston—kids!

Thanks to a free program called "Nature's Design" offered for children, youngsters aged five through eight now have an opportunity to explore the outdoors, while developing their sensory perception.

About fifteen children participated in a nature walk along the Swinefield Trail.

Glenn Bukowski, a staff member, briefed the hikers.

The young hikers were fascinated by the skunk cabbage, apple orchards, white oaks, and red maples.

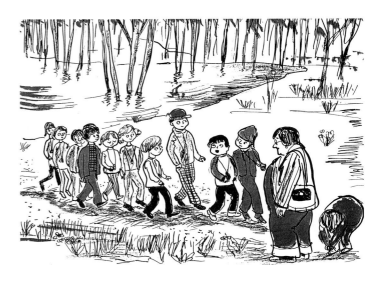

"If I knew we were playing Follow the Leader, I would have made it a little more interesting."

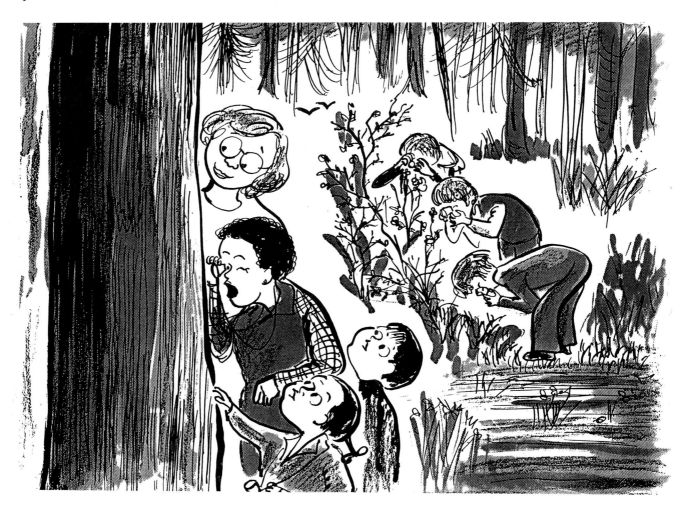

"You won't believe this—but I'm looking right into a chipmunk's kitchen."

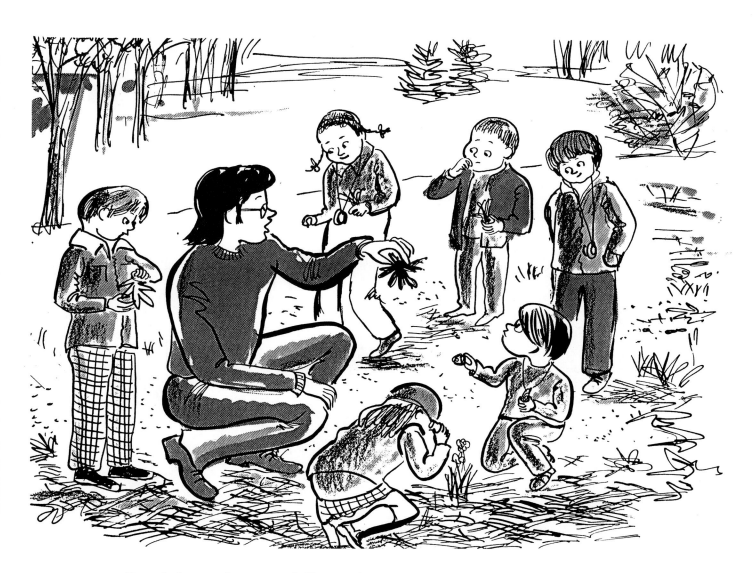

"No, hikers—there is a difference between your roots and a plant's roots."

9. Bird Banding

"Bird Banding"
February 10, 1980

Bird banding, or ringing as it is called in the British Islands, is the placing of a ring on a bird's leg to determine its longevity and migration.

The very first banding was conducted in 1707 in Turkey and Germany.

In the United States, John Audubon was the first man to band birds in 1803. He used silver threads. Now, however, bird banding is used all over the world. Banders today use aluminum.

Alice Woodcock, an employee of the Center for Environmental Studies, demonstrated the technique to children who visited the center.

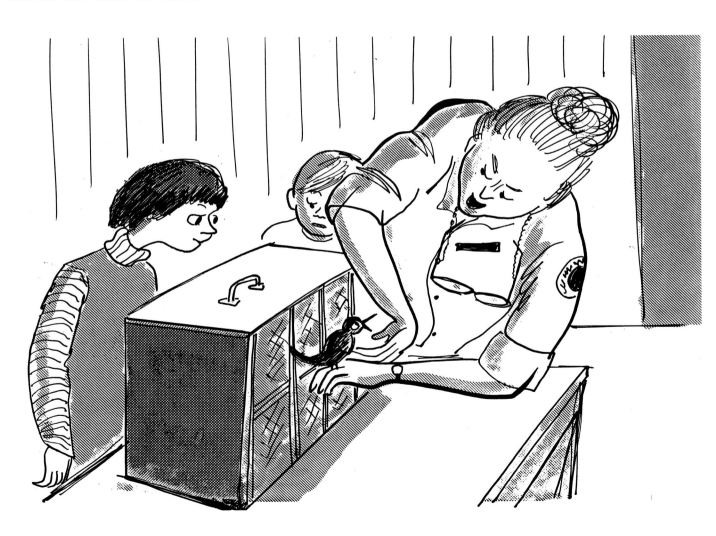

"Gee—I didn't know you were a stool pigeon!"

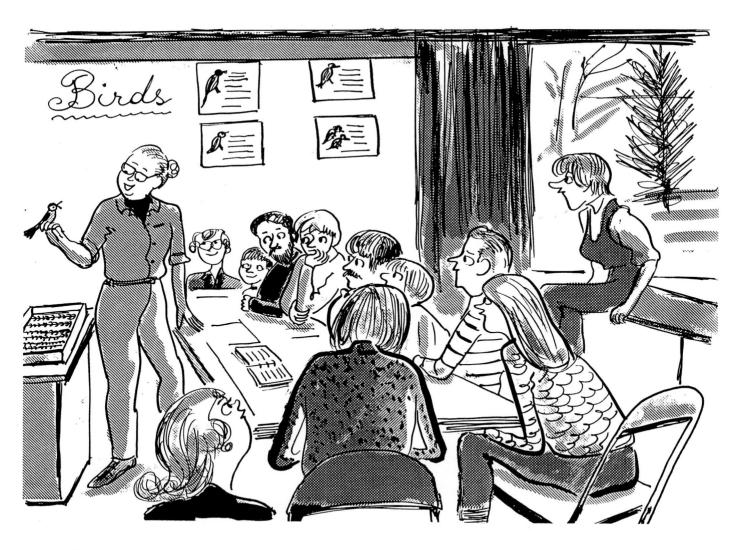

"This bird is so well behaved you would think it was stuffed, but stuffed birds can't sing."

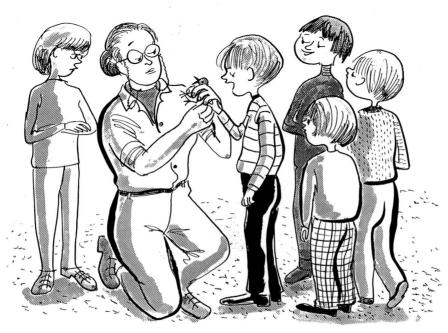

"I hope this bird gives me strength because I'll need it after school!"

10. Natural Dyeing

"Dye-Lightful"
January 18, 1981

There has been an increase in the popularity of traditional American crafts, which includes natural dyeing. Before the discovery of synthetic dyes, most came from plants, flowers, leaves, bark, and roots.

Natural dyeing involves three processes. First, dirt and excess oil must be removed from the yarn fibers. Second, the yarn must be prepared to absorb the dyes. Finally, berries, roots, and flowers must be collected to prepare the dye-bath.

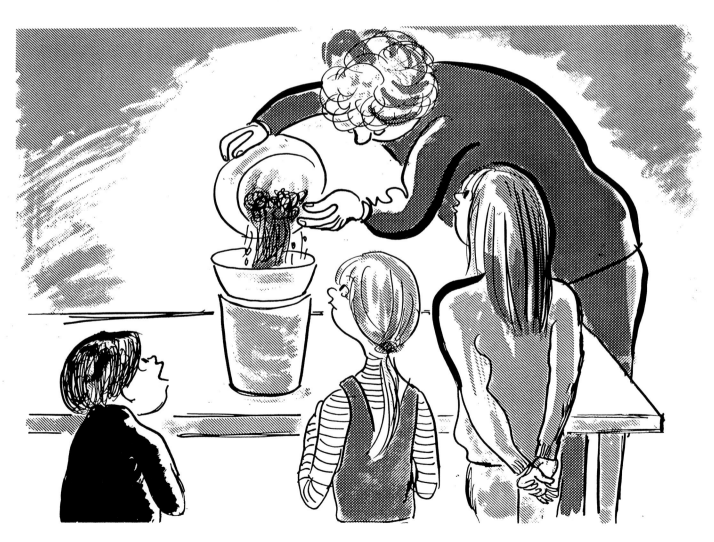

"Hey, I think that's the stuff they served for lunch at school today."

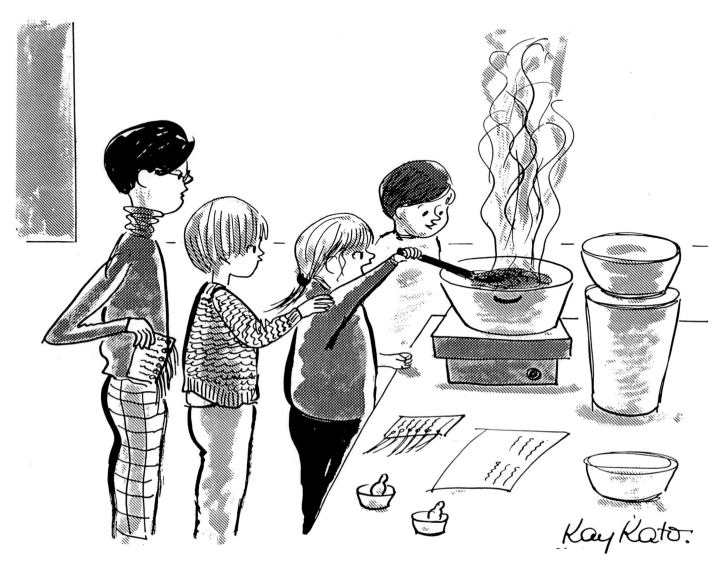

"Wait a second. My frog, Elmo, is in here somewhere."

11. Puppet Making

"On a String"
May 3, 1981

The youngsters learned puppets can be made from all sorts of everyday material lying around the house if you use a little imagination. Aluminum foil, paper bags, rags, and yarn will all come together into a thing of beauty.

According to Glenn Bukowski of Bloomfield, one of the instructors, "Rubber cement and scotch tape keep the world going."

There were two clowns, two dogs, several witches and just random people created in this fun workshop for children. And, of course, after it was over they all went home to create their own puppets, letting their imagination run wild.

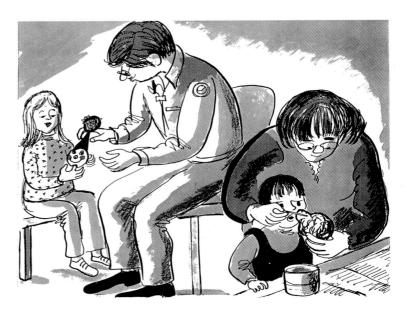

"No it does NOT look just like me."

"Keep on looking at that witch like that, she'll put a hex on you."

"Yep, this outfit would be perfect for my dog."

Kay Kato.

12. Blowing Bubbles

"Bubbly"
August 23, 1981

The mini-workshop caught the kid's fancy. Who ever heard of a child who didn't like to blow bubbles?

The "Blowin' Bubbles" workshop was held at the Center.

The children found that there are other ways to blow bubbles besides using bubble pipes or plastic wands. Bubbles don't even have to float in the air because they can also be made in containers and on table tops, or on top of all sorts of surfaces.

"I've got the bubble, how do I get the straw back?"

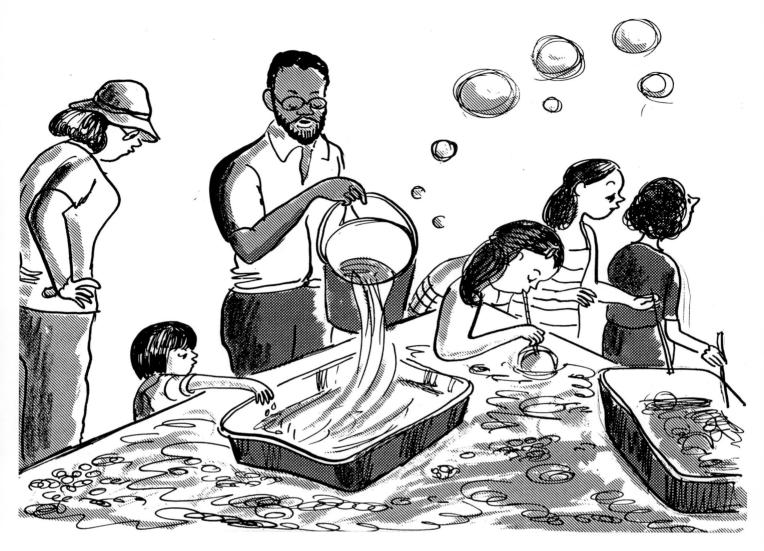

"First, let's work on the solution."

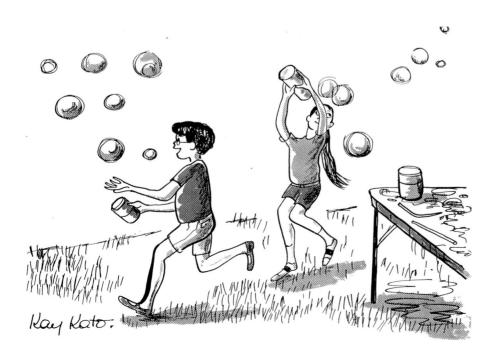

"Run a bit and catch a bubble."

141

13. Papermaking

"Wads of Fun"
January 10, 1982

Participants in a workshop had an opportunity to try their skills at papermaking.

Using the methods employed in the recycling industry, the group used a step by step procedure, beginning with shredding and ending with couching, a method used to squeeze excess water from the product.

The workshop was preceded by a lecture-demonstration given by Rowena Lavell, a staff member at the center.

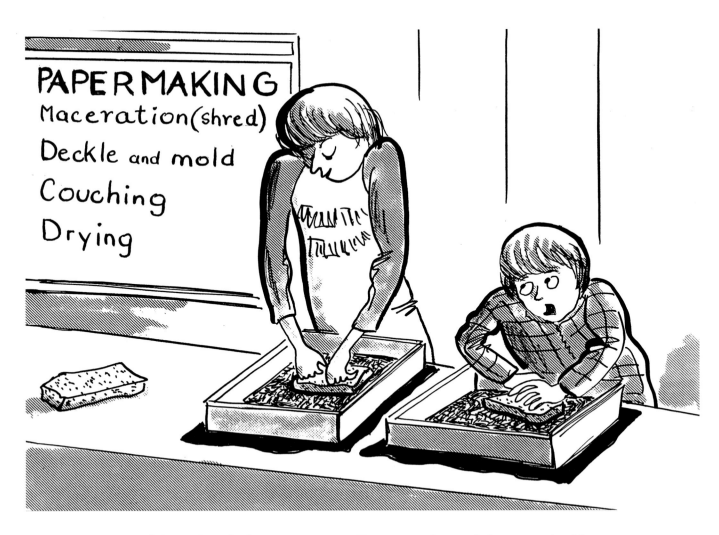

"I'm only a kid—are you sure I'm not violating labor practices?"

"My cutting is so bad—I started out making a newspaper and ended up with a memo pad!"

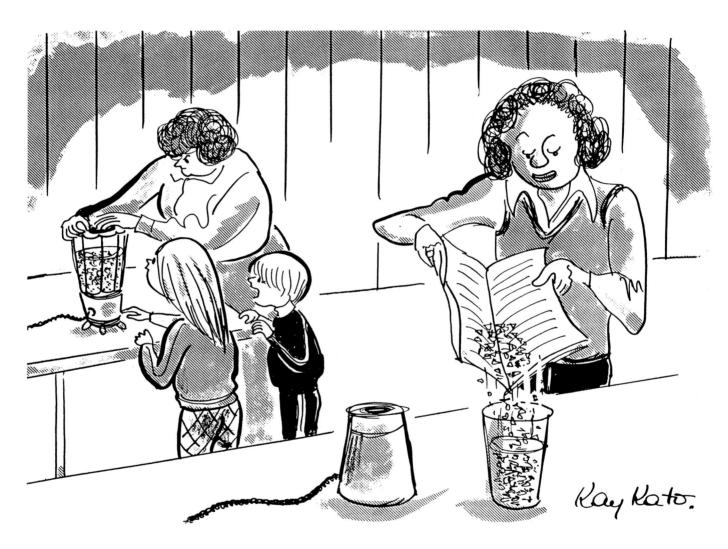

"Gee, that's the same way my mom makes milkshakes."

14. Canoe Clinic

"Can you Canoe?"
August 1, 1982

 A Canoe Clinic for beginners was held on the Passaic River.

 Participants were advised to wear knock-around clothes, just in case.

 The class started on land, as the instructor showed them how to grip the paddle.

 They were instructed in safety precautions, steering, and most difficult of all, how to distribute their weight when getting into the canoe.

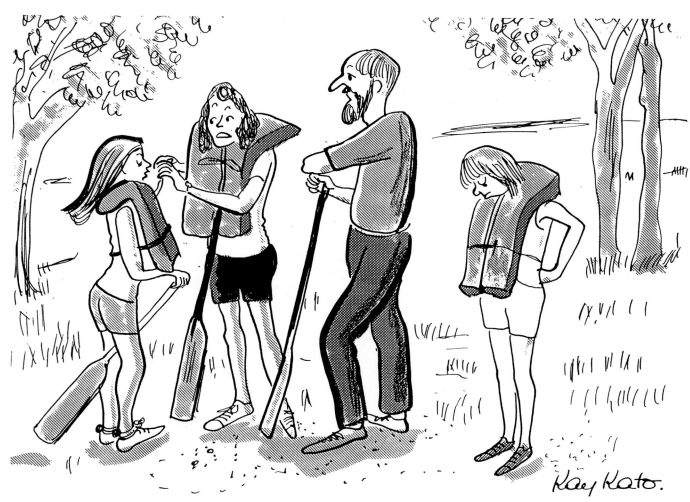

"So why are they called 'Mae Wests?' "

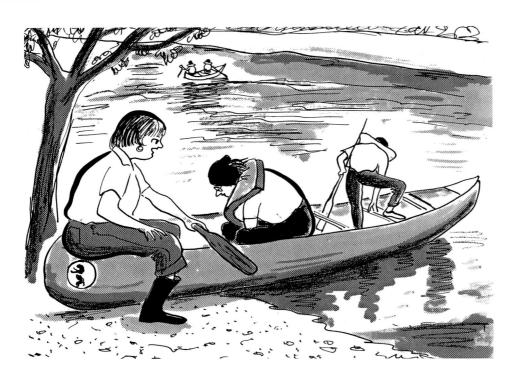

"There is no motor!"

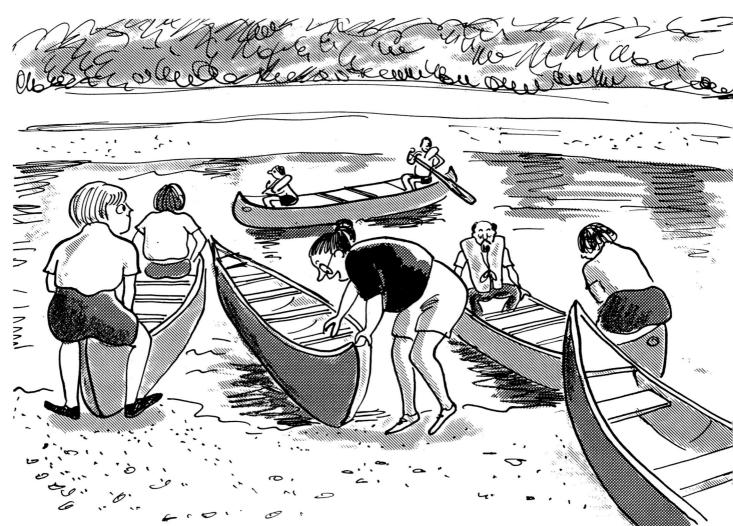

"Feels sturdier than a park bench."

15. Forager's Feast

"Movable Feast"
September 19, 1982

With trowels, bags, and instruction books in hand, participants of the "Forager's Feast" went on an environmental trip to learn what wild delicacies could be used for meals.

Trip leader Susan Kadolka led them through the forest and fields at the Center.

The toxins that make plants dangerous have a wisp quality: Some plants have leaves, twigs, and seeds that are poisonous but bear edible fruits. The group learned that other plants have berries that are harmless when ripe, but piosonous until they reach maturity. Their day spent in the forest proved fruitful.

"Oh, we can have tea. This one is sassafras."

"Hey, there's Queen Anne's lace—I think the roots are edible."

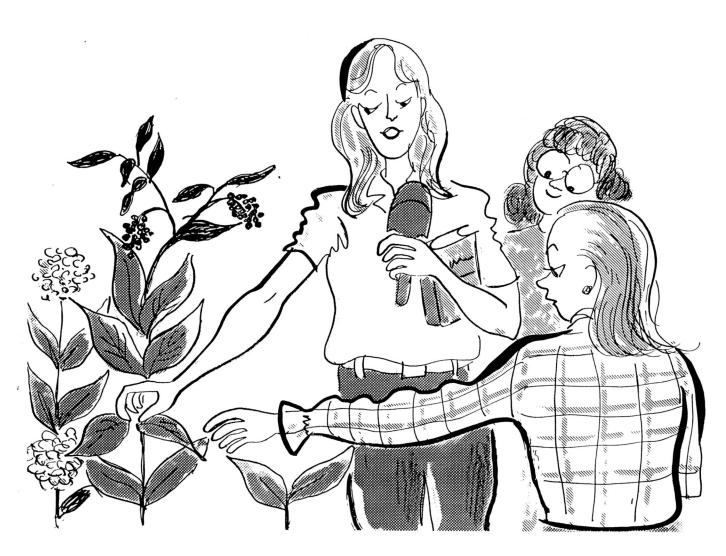

"The juice from these berries was used by our ancestors as ink."

16. Barn Dance

"Barnstrumming"
January 16, 1983

"Heehaw!"

Dances such as "Arkansas Traveler," the "Grange Dosey Do," and "Midnight on the Water" are being featured in a series of barn dances at the Center.

Caller Lew Gelfond of West Orange gets dancing partners to swing and promenade, as a banjo, fiddle, bass, and guitar strike their beat.

The players call themselves the "Orange Mountain String Band" and the atmosphere is informal as couples pair off for the "Fiddle Jig," the "Magpie," the "Texas Quick Step," and other favorites.

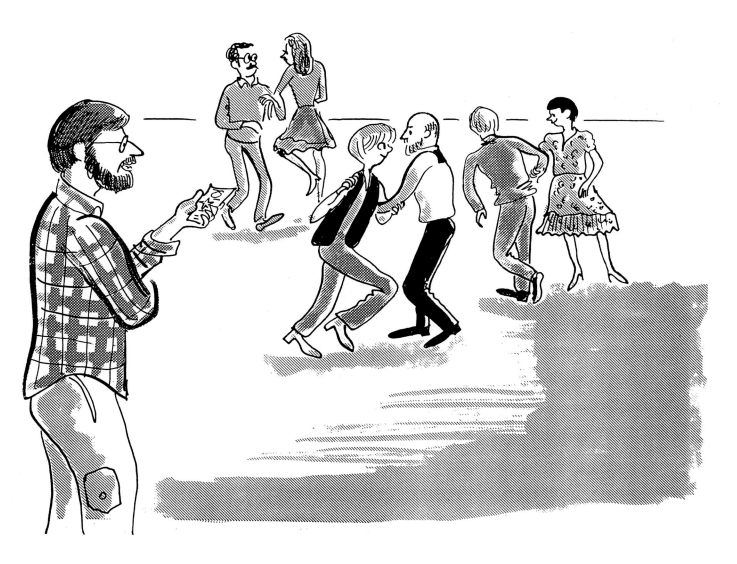

"Swing your partner!"

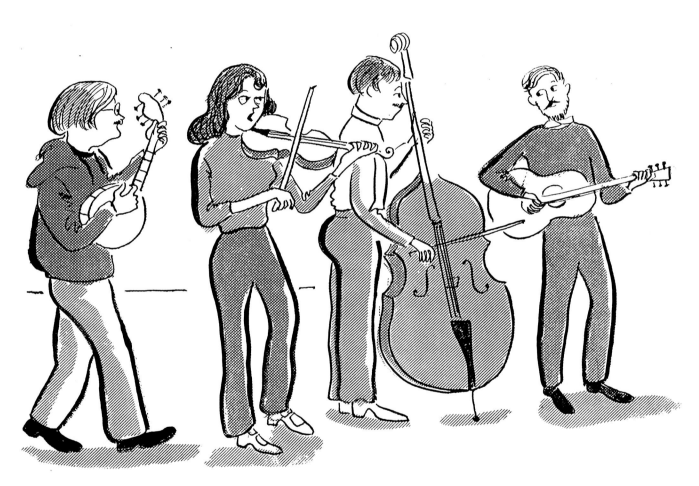

"A one, two, three."

17. Photo Expedition

"Foliage in Focus"
May 15, 1983

Christopher Lanna of Upper Montclair, a member of the staff of the Center, led a photographic expedition of West Essex Park adjacent to the environmental center.

The idea of the expedition was for amateur photographers to capture the budding of spring with a variety of camera lenses. For detailed close-up shots at low-speed apertures a tripod was needed, so hikers were somewhat loaded down as they wandered through nature looking for the perfect shot.

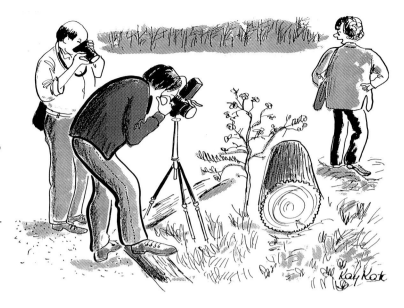

"Roll cameras!"

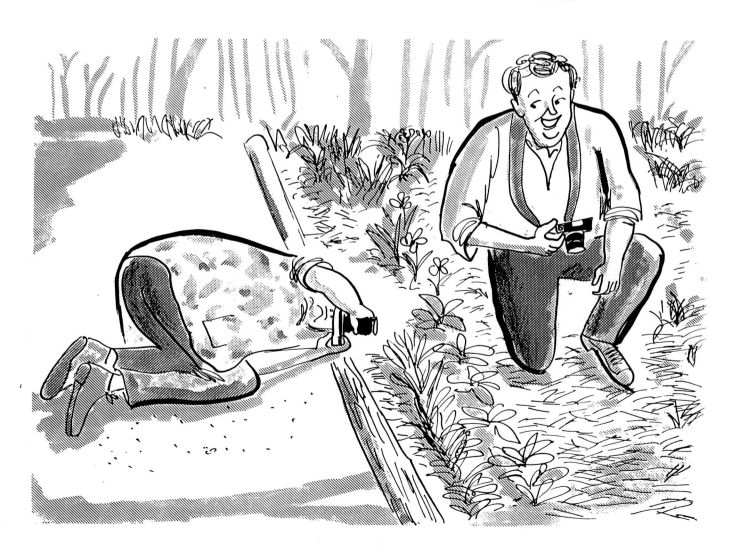

"You got an angle lens?"

18. Dances of the 1930s and 1940s

"Music Go Round"
October 2, 1983

People were swinging, jitterbugging, and jiving to the music of the 1930s and 1940s at the "Closing Circle Coffeehouse."

The music and dance coffeehouses derive their name from the ecology book, *Closing Circle*, by Barry Commoner. They are sponsored by the Folk Music Society of Northern New Jersey.

Fifty people danced to the jazzy arrangements of the group "Harvest Swing" and professional dance teachers were on hand to help everyone get in step.

"Will you dance with me?"

"You're on my left foot!"

19. Toys

"Game Plan"
December 18, 1983

It is the time of year when every child has a special toy on his list for Santa.

Mrs. Ruth B. Roufberg of Kendall Park, an independent toy consultant, conducted a workshop. And although Santa came and went very quickly, a number of parents and children were shown how toys can contribute to the learning process during the workshop.

"It's the old way of 'rocking out.'"

"Just one block at a time!"

20. Carp Fishing

"Carping"
November 25, 1984

In order to join the recent carp fishing expedition to the Passaic River, participants had to have gourmet cooking credentials.

The carp is called a "gourmet," because its bait must be cooked. A mixture of strawberries, corn, and gelatin is one variety of bait used, and white flour, corn meal, and creamed corn is another variety.

Ironically, the "gourmet" carp is one of the only fishes to be able to survive in the polluted Passaic.

"They're bigger than I thought."

"That's perfect. Don't move!"

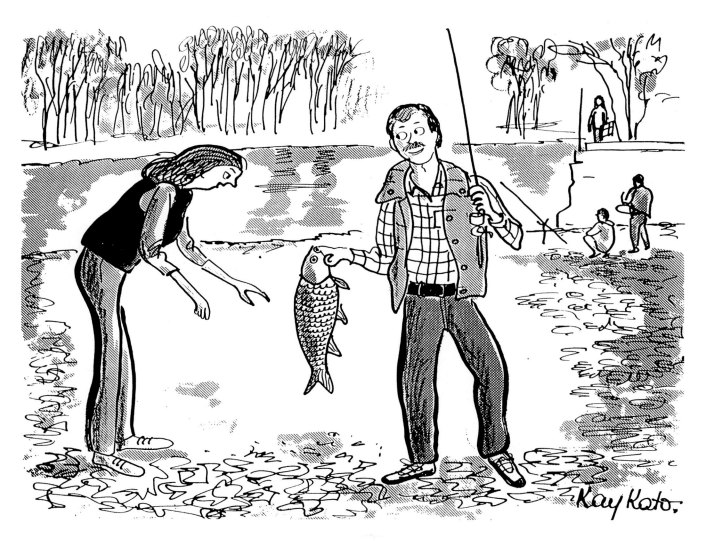

"Now, that's a fish!"

21. Yoga for Kids

"Young Yogis"
April 28, 1985

Pre-schoolers three to five years old and a few elementary school children, participated in Andrea Terry's special Yoga class.

Before doing each Yoga exercise, Terry asked the children to imagine an animal or insect that moved in a manner similar to what was called for in the exercise. When the children tried to imitate a camel, frog, or turtle, they were inspired to perform the exercise correctly.

"We just hop?"

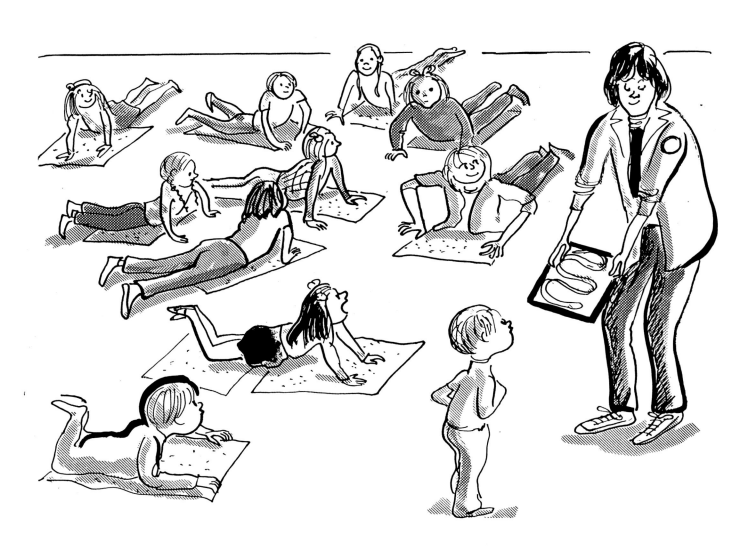

"I hate snakes!"

22. Canoe Trip

"Paddle Play"
July 13, 1986

At the "Parent and Tot Canoe Trips" on the Passaic River, Lyle Davis, one of the center's naturalists, demonstrated the proper way to hold a paddle and paddle with it. He spoke about safety rules like: No standing up in the canoe, no changing places while on the water, and no splashing.

Adults and children then traveled the Passaic upstream for one mile and returned to their starting point.

"Now, you keep that on!"

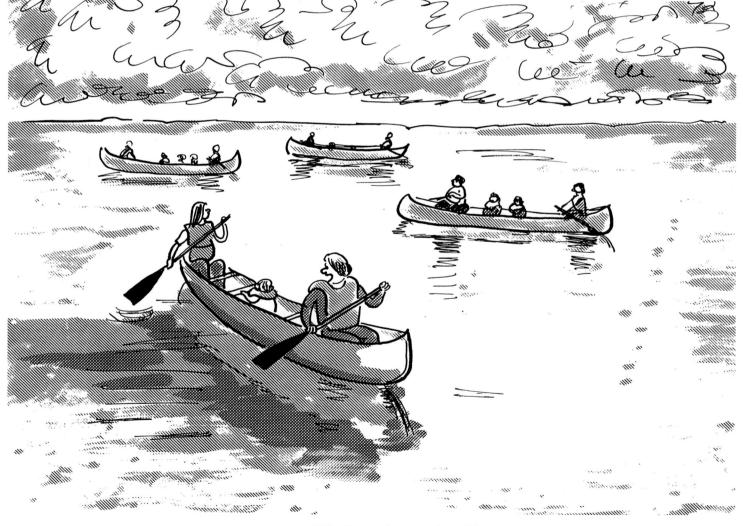

"Shall we ship to shore?"

23. Farm

"Farm Life"
October 25, 1987

The Green Meadows Farm provides children and adults with an inside look at the workings of a farm.

More than 150 animals are housed at the farm. Children are encouraged to play with or touch the animals, which include goats, sheep, ducks, rabbits, pigs, and cows.

"Here, chickie, chickie."

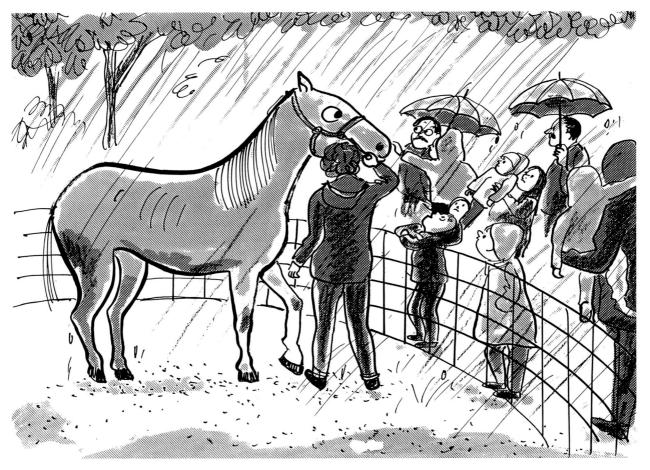

"Can we go for a ride Daddy?"

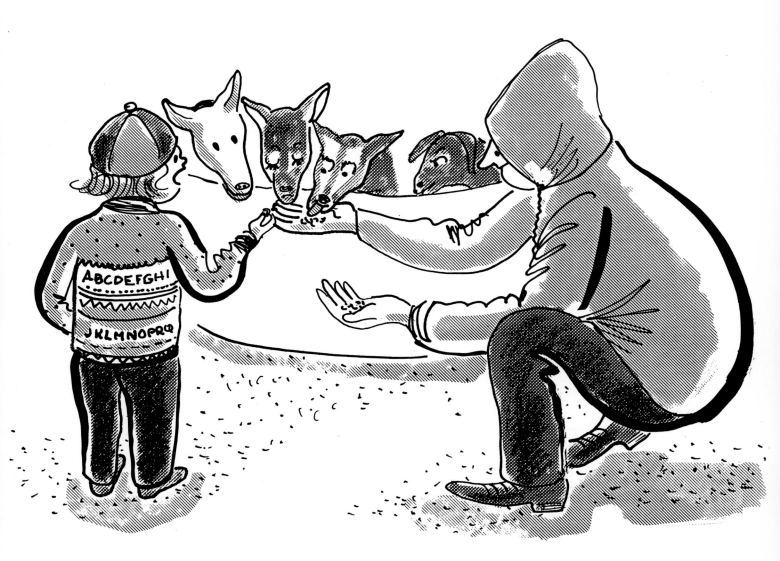

"*Wouldn't you rather have a cookie?*"

"Sunny Side Up"
September 4, 1988

A largest sunflower contest was sponsored in an effort to promote an appreciation for the miracle of growing plants. Besides, the contest encouraged people to beautify their neighborhoods and gave participants an opportunity to cultivate plants.

The sunflower is a native of the American Southwest, but it is now grown even in Russia. Those who participated in the contest had to grow the plants from seeds.

"Thirteen inches, and it was still growing this morning."

"I'm the one who grew it, so my name should be on it."

"Someday I may be that tall, too!"

"I would guess this is a winner."

25. Firewood

"All Fired Up"
January 1, 1989

"Firing up for Winter," a program presented by the Center was geared to fireplace buffs.

It covered the best kind of wood for fireplaces, using a chainsaw properly, and how a fireplace should be designed.

How to split firewood also was on the agenda, as well as the best way to get a fire started and how to keep it alive.

The lecture was conducted by Scott Butterfield, a member of the staff at the Center.

"Should I go ahead with it?"

"This would make a nice table."

"His face is turning red."

26. Beekeepers

"Honey of a Day"
June 4, 1995

The Honey Bee Fair, sponsored by the Essex County Beekeepers Society, introduced visitors to the honeybee that pollinates fruits, vegetables, and other crops.

The visitors of the fair learned the types of bees found in a colony, equipment needed to keep them, and proper care of the colony.

"Look!"

"Is he crazy or something?"

"Geee, that's interesting."

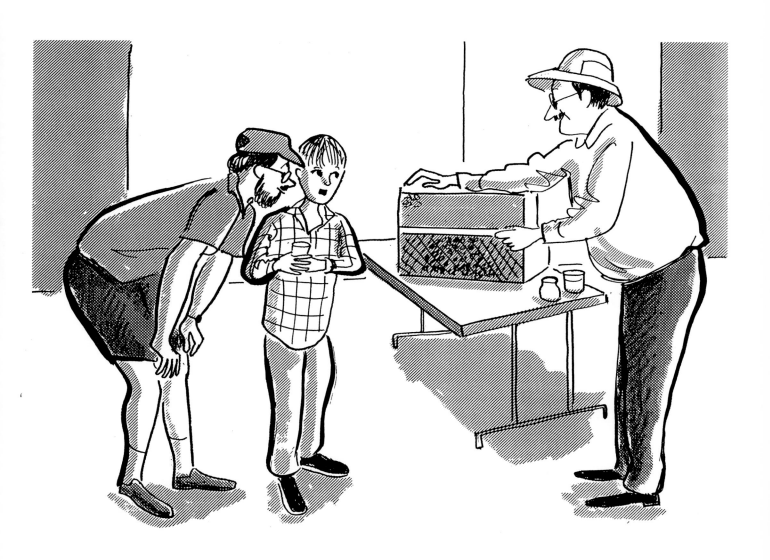

"*Son, don't be scared.*"

Chapter 4 **Arena**

1. Oriental Holiday

"Concert on Ice"
August 21, 1966

Ice in the summer is often a difficult thing to come by. For one thing, it's in great demand; for another, it melts.

But there was plenty of ice at the South Mountain Arena as the Essex County Park Commission and the Essex Skating Club of New Jersey presented a "Pop Concert on Ice."

The event attracted many refugees from the outdoor heat wave.

The theme of the production was an Oriental Holiday, with a junior precision group dressed in Japanese kimonos and geisha wigs.

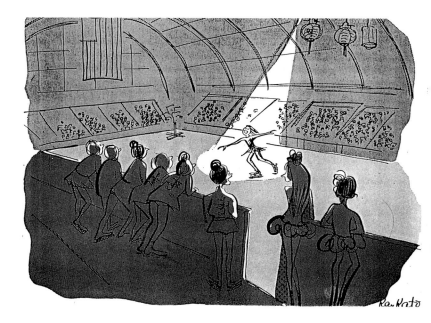

"I'd like to see her try that with one of these wigs on her head!"

"Smile, Helen! There are two cute guys in the first row."

2. Senior Jamboree

"Laugh and Learn"
May 25, 1975

Senior citizens can also learn and have fun at the same time. So the Senior Citizens Office of Essex County entertained and taught the golden agers at a Senior Citizens Jamboree at the South Mountain Arena in West Orange.

Representatives from agencies and municipalities taught the elders everything they needed to know about health clinics, transportation services, trust funds, and wills—but were afraid to ask.

The seniors left the jamboree after having a good time while learning something in the process.

"This is fun, but I'm better at ballet dancing."

"On the Good Ship Lollypop . . ."

"It's a good thing the little lady stayed home. She's the jealous type."

"Can you do the 'jerk'? "

3. Girl Scouts' Bicentennial

"Girl Scout Salute"
May 30, 1976

More than 150 Girl Scout troops attended the Girl Scout Council of Greater Essex County's Bicentennial Festival.

There were displays focusing on both the nation's history and the activities of the scouts.

One of the more striking exhibits the scouts created was a seven-foot rag doll named Greta, which sat in a chair wearing red nailpolish and holding several balloons. She was dressed in the traditional scout green, and was also wearing a beautiful smile.

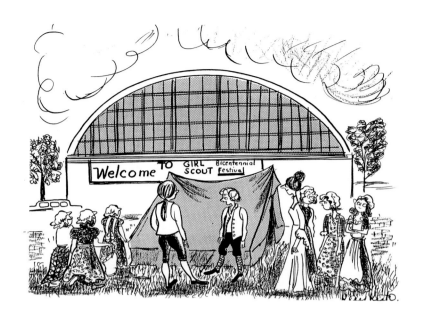

"I don't think they make tents with restrooms anymore."

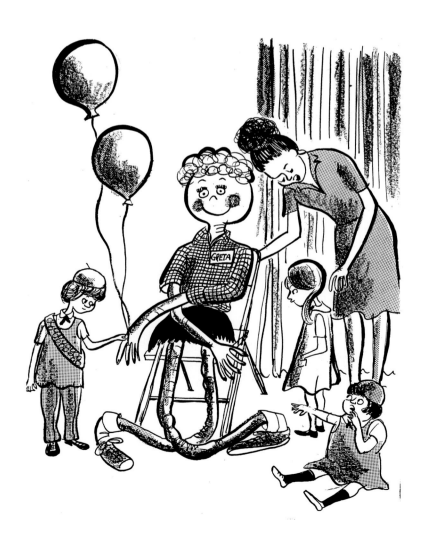

"Everybody grows up, even ragdolls."

"I like it, but there's no room for my cat."

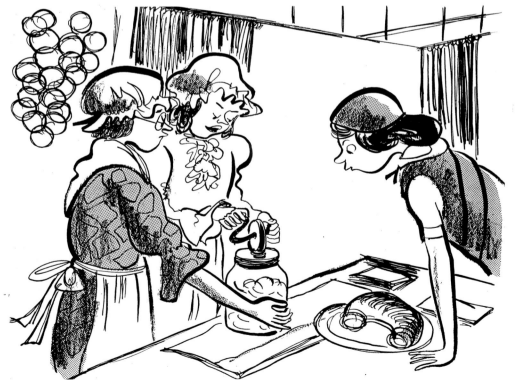

"Wouldn't it be easier to just go to the supermarket for butter?"

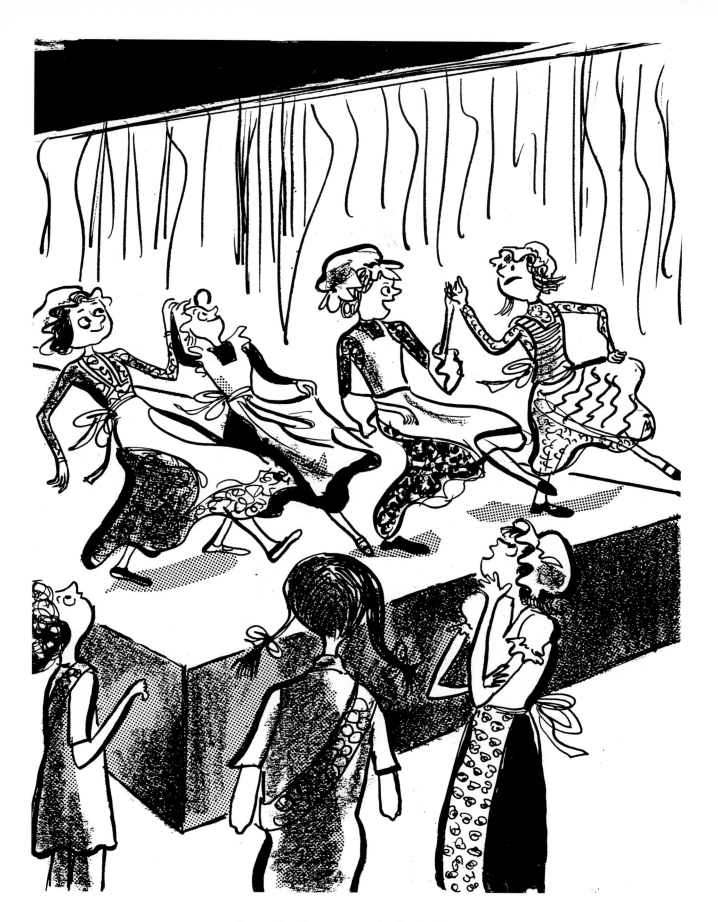

"You think we're ready for ballet?"

4. Cultural Heritage

"Ethnic Delights"

June 25, 1978

Showcase '78, the first annual Cultural Heritage Festival, began with a parade of nations complete with native costumes.

Exercises were presented by the Asian Cultural and Heritage Group, the Nutley Italian-American Civic Association featured the Bel Canto Singers, the Jain Society of India demonstrated yoga exercises, the Covered Bridge Squares did American dances, and the New Jersey American Indian Center gave lectures.

The festival was sponsored by the Essex County Board of Freeholders.

"Maybe it would be easier if you pretend you're stringing sneakers."

"A lot of people keep asking me if this is the arena over here."

174

5. Festival

"Good-Old Time"
September 28, 1980

The seventh annual jamboree featured jazz entertainment, outdoor flea markets, hay rides, an antique car show, train rides, and other cultural workshops.

A fashion show of oldtime costumes and a parade featuring Miss Liberty also headlined the festivities.

Other specialized events included an art show featuring Essex County artists, yoga, quilting, weaving, egg decorating, needlework, instrument making, and sculpturing.

Essex County Executive Peter Shapiro gets talked into buying a pot holder from one of the crafts sellers.

"That dress looks like something right out of Gone with the Wind.*"*

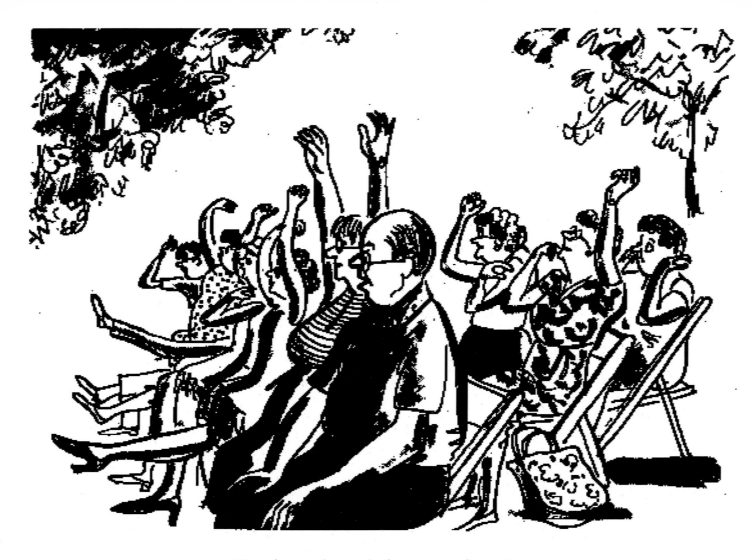

"Bend, stretch, crack those weary bones."

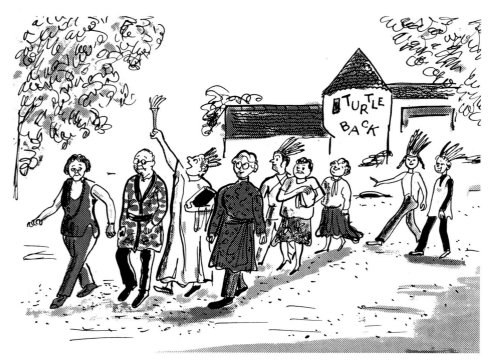

"Miss Liberty bears her torch and spreads tranquility over the festival."

6. Senior Festival

"Gray Matters"
October 3, 1982

A parade, an arts and crafts exhibit, a flea market, and Governor Kean are but a few of the things that lured several thousand senior citizens to a cultural festival.

Ben Schaffer of Livingston was coordinator of the festival.

A job fair, titled "Ability is Ageless," an antique car display, a puppet show, a hay ride, and rides on a Holiday Inn double-decker bus added to the festivities.

"That spine doesn't look very straight to me."

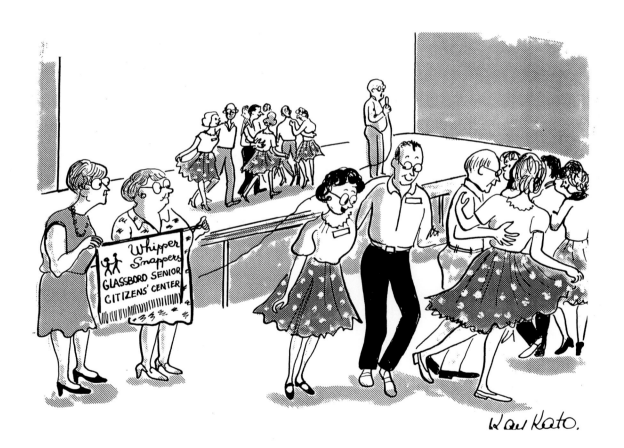

"Put your left foot out, then I'll whirl about."

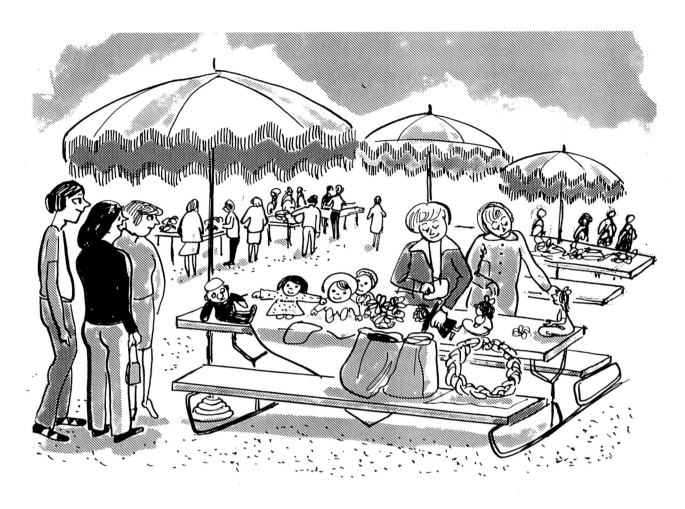

"Gee! This is a great festival!"

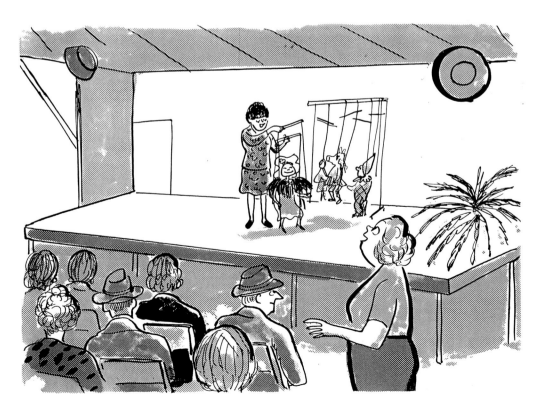

"My God! That looks like Aunt Judy."

"It's never too late to have a fling!"

7. Energy Expo

"Watt's New?"
February 6, 1983

The South Mountain Arena in West Orange hosted the Energy and Home Improvement Expo, with the theme of "How to Save Energy."

The exhibition featured more than one hundred exhibitors, most of them New Jersey companies, specializing in home appliances, boilers, insulations, spas, waterbeds, and similar items.

There were also more unusual items, such as a solar heater that fits into a window like an air conditioner and a twenty-five-foot windmill that generates electricity.

Public Service Electric and Gas Company had a booth where they displayed a model house, designed to maximize energy efficiency through the proper use of insulation, caulking, and weatherstripping.

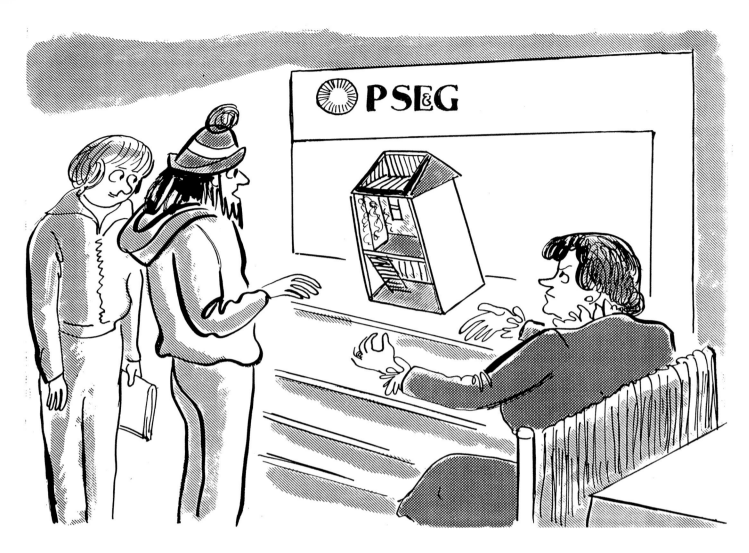

"I could insulate a house that size."

"This will thaw out my feet!"

"I don't think it will fit in our backyard."

"It's a funny looking slide."

"Sunshine's a better investment."

8. Ice Hockey, Kids

"A Goal in Life"

January 8, 1984

Playing for either the Devils, Rangers, or Islanders someday was on the minds of most of the children who skated at the South Mountain Arena in West Orange.

Mites, Squirts, PeeWees, Bantams, Midgets, and Junior "C" hockey players, encompassing boys and girls in the age range of seven to nineteen, skated down the ice with a vengeance, trying to get the puck past the goalie.

Even some two-, three-, and four-year-olds tried some light hockey, while parents stood around the rink cheering on their kids.

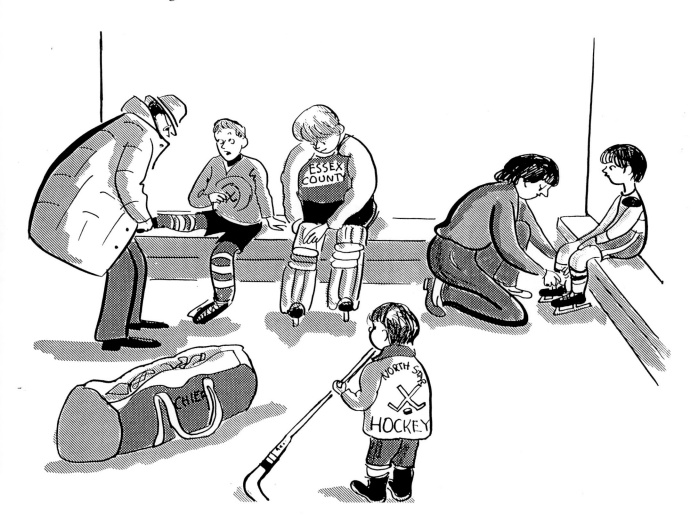

"Get them real tight!"

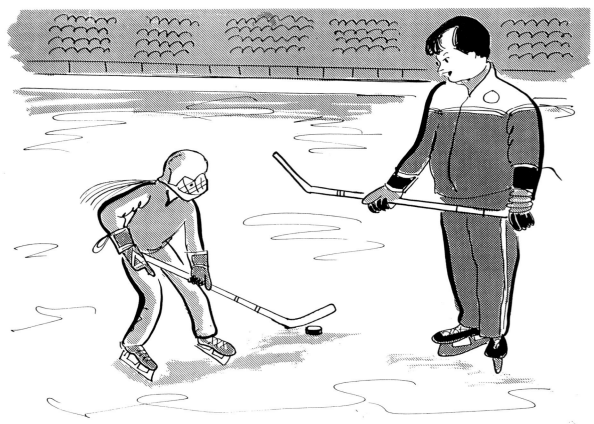

"It's all in the wrist."

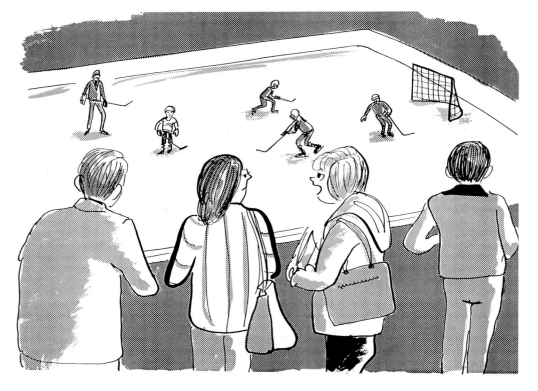

"My boy will center for the Devils someday."

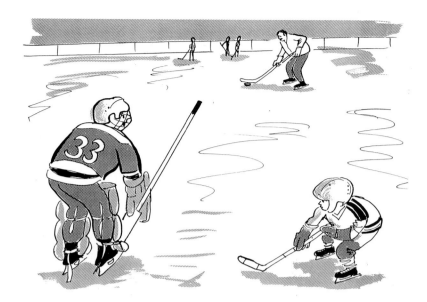

"Try and stop this one!"

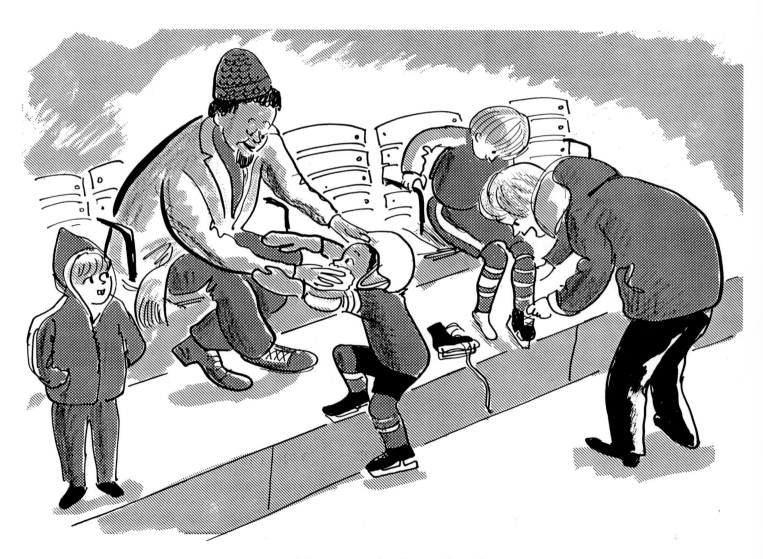

"Go on, get back out there!"

9. Dog Show

"A Breed Apart"
August 5, 1990

The Twin Brooks Kennel Club held its forty-fourth annual All-Breed dog show where more than 1,200 dogs of 122 different breeds competed for eight prizes: Best Sporting, Herding, Terrier, Hound, Toy, Non-Sporting, Working, and Best in Show.

Joan Confort of Watchung chaired the show, which attracted competitors from as far away as Tennessee and Georgia.

The Best in Show prize was awarded to a red-blonde Pomeranian from New Jersey, whose father had won the show six years ago.

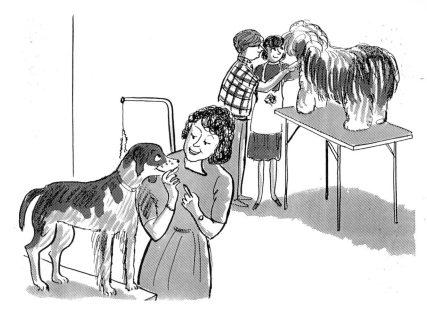

"Remember to smile at the judges, Fido."

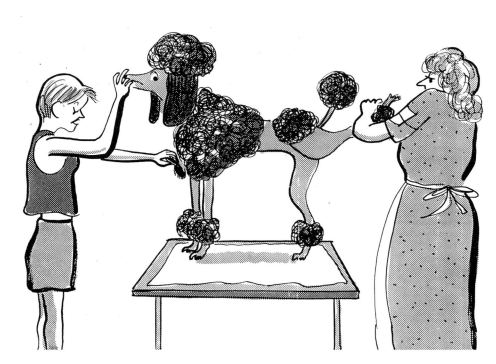

"A poodle's life is not a happy one."

"Look, Ma, here's one by Yves St. La Pooch!"

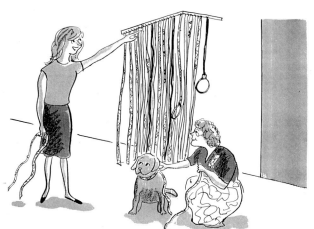

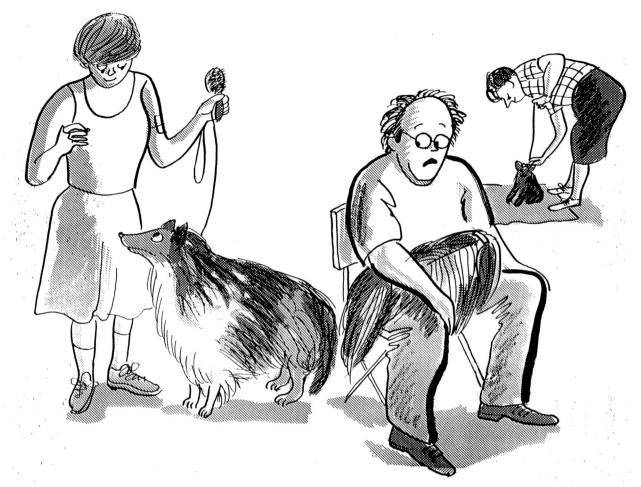

"*Not another miniature collie!*"

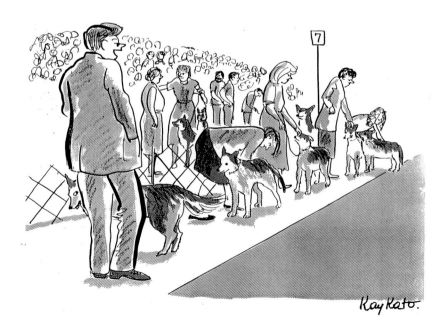

"*Don't worry, Sparky. There's not another dog here as fine as you.*"

10. Ice Skating

"Skaters, Away!"
February 27, 1994

The interest in ice-skating generated by the Winter Olympics in Lillehammer, Norway, has brought skaters out in droves. On one Saturday afternoon youngsters far outnumbered adults making the rounds on the ice.

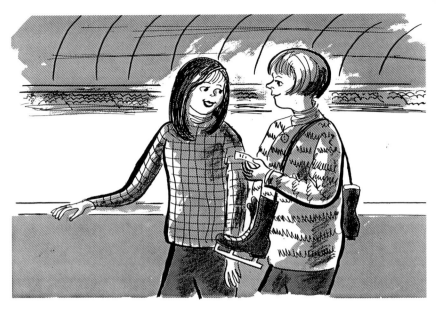

"I can't believe you signed that receipt 'Tonya Harding!' "

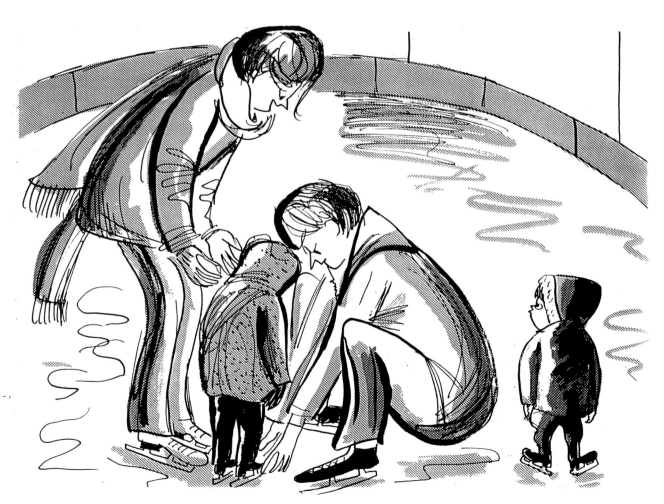

"I'll bet Dan Jansen knew how to tie his own skates by your age!"

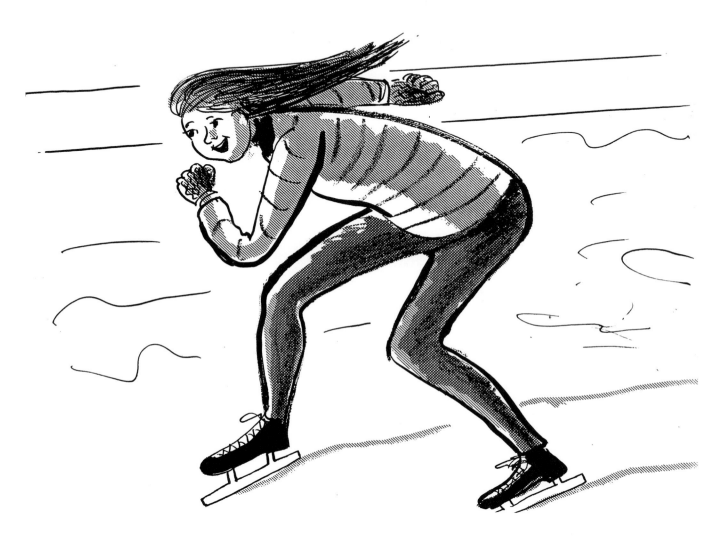

"Bonnie Blair, eat your heart out!"

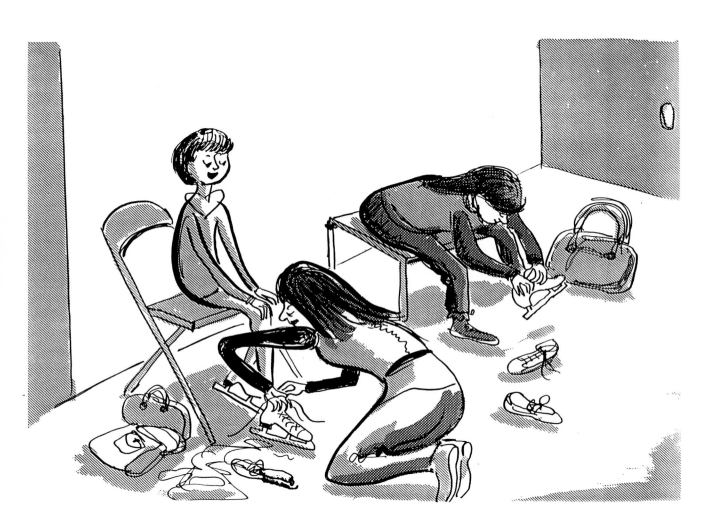

"The fit is fine, but do you have them in any other colors?"

About the Artist

Kay Kato received art training at Pennsylvania Academy of Fine Arts. After schooling, she devoted her time to oil painting.

During World War II, as the Boston representative for the Committee on War Cartoons, Kato volunteered cartoons for the Office of War Information (O.W.I.). A cartoon about war bonds for the U.S. Treasury Department was chosen by *The New York Times* to be published in their magazine. Kato also sketched servicemen at USO Clubs in Fort Dix, New York, Long Island, and Boston, and did "Becoming a WAAC," a three-page spread in PM.

Kato's published works from 1941–1995 began with her first cartoon being published in *This Week Magazine*, the largest circulation Sunday supplement in the country. She then illustrated "The Perfect Squelch" and the "You Be the Judge" stories for the *Saturday Evening Post* for many years and contributed cartoons to them as well. Some of her humorous illustrations appeared in *The New York Times* for the Parent and Child articles in the magazine. Kato also did full-page spreads for the *Christian Science Monitor*, as well as for *Suburbia Today*. Her artwork appeared in *Parade, Liberty, Nation's Business American Weekly, TV Guide, King Features Syndicate, Boston Globe, Boston Traveler, Boston Herald*, and *Philadelphia Bulletin* which published a series of her drawings about Independence National Historic Park in their Bicentennial Souvenir edition. *The Staten Island Advance* published Kato's spreads of pictorial reporting on the full front page of their Lifestyle section. For *The New York Herald Tribune*, she painted a cover for their *Today's Living* magazine section, depicting a school fair. This magazine cover featured ninety people. The 20" by 24" casein painting on gesso board was exhibited at The Newark Museum show in 1993.

For the *New England Telephone and Telegraph Company Magazine* Kato sketched a two-page spread, portraying all of the company's executives around the conference table. She received an assignment from *Harper and Row* to design a book jacket for *Television-Radio Audience and Religion*. For *Harper and Row*, Kato con-tributed a cartoon for "Marriage and Family Reality." Three of Kato's cartoons were included in the book *Best Cartoons of the Year* in 1942 and 1943, and she did the *AT&T Magazine* cover in 1954.

On September 27, 1964, in the *Sunday Star-Ledger*, the first of Kato's cartoon-columns appeared, featuring the construction site for building the Rutgers Law School in Newark. The next cartoon was an LBJ barbecue on the Engelhard estate in Far Hills. Now, thirty-one years later, adding up all the Sundays, 8,500 individual drawings appeared, covering the entire state, without ever missing a week. The subjects covered were: environment, ethnic groups, hobbies, lifestyles, sports, culture, historic places, leisure, cities and towns, transportation, business and occupation, education, among others.

The artist's awards and honors include a first prize award for cartoons from the New Jersey State Federation of Women's Clubs in 1977 and 1978; a Plaque Award from The Newark Museum Paleontology Program in 1979, from the Livingston Historic Society in 1990, and from the American Heart Association; and a special reception for the artist was given by Governor Kean at the State House on December 28, 1989, honoring the cartoon-column for appearing twenty-five years.

Kato sketched many celebrities from life: President Lyndon Johnson, Lynda Byrd Johnson, President Nixon, King Hussein of Jordan, Stalin's daughter, Svetlana (1967), Hubert Humphrey, Bob Hope (1968 and 1985), Phyllis Diller (1969), Margaret Truman, Van Cliburn, William Randolph Hearst, Victor Borge, Mayor La Guardia (1943), Mayor John Lindsay, Senator Barry Goldwater, Abba Eban, Ruggiero Ricci, Buffalo Bob, Arlene Francis, Count Basie, Jerome Hines, Bobby Riggs, Milicent Fenwick, Ozzie and Harriet Nelson, Yehudi Menuhin, Fran Allison, Governors Hughes, Cahill, Meyner, Byrne, Kean, and Whitman.

Kay Kato's one-woman shows were held at the Boston Public Library, "Cartoonist Looks at the War," 1945; R. C. Vose Galleries, Boston, 1945; The Newark Museum, including ninety

published originals from her *Sunday Star-Ledger* column which were exhibited and the show was televised on WOR-TV, June, July 1980; again at The Newark Museum, July 14 to September 19, 1993; New Jersey Network News Channel 50 covered the show on July 14, 1993; Newark Public Library, drawings from her *Sunday Star-Ledger* column about events in New Jersey libraries, these originals are now in their Special Permanent Collection, Governor Byrne attended the reception, March 1992; Montclair State College, exhibited published cartoon-columns from the *Sunday Star-Ledger*, these drawings were also published in book form by the college, 1987; and Belleville Public Library, fifty published originals remain in their Permanent Collection, 1989.

Other one-woman shows in libraries include: South Orange, Maplewood, Bloomfield, Millburn, West Caldwell, Passaic, and Livingston, 1956–1992.

Kato also participated in the following group shows: Pennsylvania Academy of Fine Arts, 1941; American Fine Arts Society Galleries, New York, 1943; Contemporary New England Artists, Boston, 1950; Montclair Art Museum 1953 and 1956–1957 (New Jersey State Show) oil paintings; International Salon of Cartoons, "Man and His World," Montreal, Canada, 1975–1988.

Kay Kato instructed classes at the Cambridge Center for Adult Education and Montclair and Maplewood Adult Schools. Three of her programs, "Laughing at Life," "Sketching Reporter," and "Cartoon Gallery of Celebrities," were presented in schools, clubs, and cruise ships. Kato also appeared as a television guest cartoonist on the following television shows: *Tonight Show*, *Jack Parr Show*, *Jimmy Dean Show*, Library Program Channel 3, and TV Stations in Boston, Denver, Philadelphia, Detroit, Washington, D.C., and Hollywood.

Kay Kato is listed in *Who's Who in American Art* and *Foremost Women in Communication*.

SUNNY SIDE UP

The Center for Environmental Studies presented its first outdoor programming in an effort to give growing plants through the winter for transplanting in the spring...

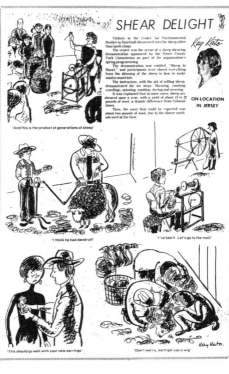

SHEAR DELIGHT

Visitors to the Center for Environmental Studies in Roseland discovered uses for sheep other than lamb chops.

The center was the scene of a sheep shearing demonstration sponsored by the Essex County Park Commission as part of the organization's spring programming.

The demonstration was entitled, "Sheep to Shawl," and participants were shown everything from the skinning of the sheep to how to make woolen materials.

The instructors, with the aid of willing sheep, demonstrated the six steps: Shearing, combing (carding), spinning, washing, dyeing and weaving.

It was explained that in most cases, sheep are sheared once a year, with a yield of about 15 to 22 pounds of wool, a drastic difference from Colonial times.

Then, the most that could be expected was about two pounds of wool, due to the slower methods used at the time.

'And this is the product of generations of sheep'

'I think he had dandruff' 'I've had it. Let's go to the mall'

'This should go well with your new earrings' 'Don't worry, we'll get you a wig'

Kay Kato.

ZOO'S WHO

The animals have known it for years: there's no better spot for people-watching than a zoo.

One of the most interesting zoos around is the Essex County Park Commission's Turtle Back Zoo in the South Mountain Reservation, West Orange, where the animals have almost as much mobility as the two-legged visitors.

Star-Ledger roving artist Kay Kato took her mobile sketch pad to Turtle Back last week, and liked what she saw so much that she went back a second time.

Where else, asks Kay, can you sketch a llama with a buffalo looking over your shoulder; be kissed on your drawing arm by a friendly calf; or lose a bite of paper to a hungry goat?

Kay's visits were helped along with advice from animal keeper Dennis Farrand of Newark. Some geographical notes were offered by Mrs. Jan Schoffman, a travel lecturer from West Orange.

Mrs. Schoffman was on a busman's holiday, by the way, with her youngsters Daniel, 11, Carol, 8, and Sharon 6.

Another zoo-goer who might recognize himself is Chester Morris, eight-and-a-half, of Parsippany, but the captions, as usual, are purely imaginary.

The African Unity Dancers demonstrate some fancy footwork

BRANCH OUT

The stars came out in Newark's Branch Brook Park for Summerfest '85, a series of free concerts and performances sponsored annually by the Essex County Department of Parks, Recreation and Cultural Affairs.

Two of the groups featured in the outdoor productions included Gallman's Newark Dance Theatre and the African Unity Drummers and Dancers, a troupe dedicated to the preservation of traditional African music, dance and costume.

Concert goers spread their blankets and picnics, settled back in their lawn chairs and enjoyed the show.

Honestly, dear, an octopus does not eat little girls!

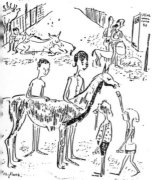

Hey, mom. This stuff tastes good!

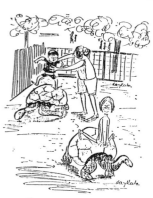

I'll race you home, mom!

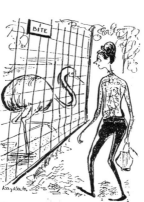

That's funny. I thought I saw the kids here a minute ago

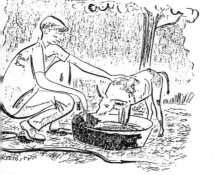

Open-air dining at Branch Brook Park